Gustave Moreau
The Watercolors

Pierre-Louis Mathieu

Gustave Moreau
The Watercolors

Hudson Hills Press
New York

First American Edition

© 1984 by Office du Livre S.A., Fribourg (Suisse)
Translation © 1985 by Hudson Hills Press, Inc.

Published in the United States by Hudson Hills Press, Inc., Suite 301, 220 Fifth Avenue,
New York, NY 10001.
Distributed in the United States by Viking Penguin Inc.
Distributed in Canada by Irwin Publishing Inc.
Distributed in the United Kingdom, Eire, Europe, Israel, and the Middle East by Phaidon Press Limited.
Distributed in Japan by Yohan (Western Publications Distribution Agency).

Editor and Publisher: Paul Anbinder
Manufactured in Switzerland.

 This book was printed by Hertig+Co. AG, Biel, in 1985
 Setting: Hertig+Co. AG, Biel
 Photolithographs: color by Planning Group; black-and-white by
 Atesa Argraf S.A., Geneva
 Binding: H.+J. Schumacher AG, Schmitten
 Layout and production: Marcel Berger

Library of Congress Cataloguing-in-Publication Data

Mathieu, Pierre-Louis.
 Gustave Moreau, the watercolors.

 Translation of: Gustave Moreau, aquarelles.
 Bibliography: p.
 1. Moreau, Gustave, 1826–1898—Criticism and
 interpretation. I. Moreau, Gustave, 1826–1898.
II. Title.
ND1950.M67M3713 1985 759.4 85-14732
ISBN 0-933920-31-8 (alk. paper)

Contents

Introduction

The Dream Builder

Most French painters of the nineteenth century, beginning with the Romantics, were keen and dedicated watercolorists, having learned the technique from English landscape painters traveling on the continent after the Napoleonic wars. But for most of them watercolor was solely for personal use and study prior to making an oil painting and, as such, not intended for public exhibition. Géricault, Delacroix, Daumier, Manet, and Cézanne, to name but a few, were all superb watercolorists; but it was only after their deaths and the dissemination of the contents of their studios that it became possible to discover the importance this technique had for their working methods, the essential conception of their paintings, and even the evolution of their styles. Cézanne cannot be properly understood without a knowledge of his watercolors—John Rewald has counted more than 650 of them—and it is known that Wassily Kandinsky's first abstract work—and therefore the first in the history of painting—was a watercolor. In this respect we shall see in this book that Moreau can claim a certain precedence.

Gustave Moreau was deeply devoted to the medium of watercolor and preceded or followed nearly all his oil paintings with one or more related watercolors. At his death his studio contained around four hundred of them, not counting drawings highlighted with color. They played a crucial role in the elaboration of his paintings. Like many of his fellow artists, he would entrust them with his artistic secrets: the bold, strange, but often intimate ideas that even the most reckless would not dare or even think to publish. By agreeing, after much delay, to transform the artist's studio into a museum, the French state has enabled all these watercolors, which are usually too simplistically categorized as sketches, to be preserved under one roof.

Unlike other nineteenth-century painters, Gustave Moreau painted water-colors for their own sakes, as finished works bearing the same titles as his oil paintings. In this respect he was exceptional even among contemporary history painters, just as Ingres, with his lead-point portrait drawings, bestowed his noble style on what was for him a lesser genre.

It is most likely that Moreau at first made watercolors after his own works as copies of his successful salon pieces and in response to the demands from admirers. Thus there exists a corpus of works that repeat the artist's most important masterpieces, but in watercolor. As he did not like simply to copy his own paintings, the many variations, often painted long after the original, are not just reproductions of a prototype.

In 1866 he began showing original watercolors in the drawings section of the annual Salon, which was rare at that time for a painter practicing that noblest of genres, history painting. At first these were simply designs, mainly for enamels, but after 1876 he grew bolder and exhibited very large watercolors such as *The Apparition* and *Phaeton*.

Among his admirers were two who particularly encouraged him in the development of his watercolor technique, probably because they realized Moreau's special talent for it; they were Charles Hayem and Antony Roux. The former was a passionate collector of Moreau's watercolors and did not conceal from him his intention of offering them to a museum, which he did the day after the artist's death, leaving the finest to the Musée du Luxembourg; they are now in the Cabinet des Dessins at the Musée du Louvre. The latter urged Moreau to undertake the illustration of La Fontaine's *Fables* and for six years goaded him until he had managed to obtain sixty-four watercolors.

In 1886, as he appeared to be withdrawing more and more from public life, not having entered a painting in the Salon since 1880, Moreau authorized the Goupil Gallery in the rue Chaptal, Paris, to organize a one-man exhibition of his work—the only one during his lifetime—which comprised only watercolors, as if he wished posterity to have this as final public evidence of his activity as a painter.

Attached as he was to his work, Moreau while still alive agreed to sell only just over four hundred of his many paintings, more than two hundred of which were watercolors. This shows the importance to him of a genre generally considered to be inferior. A technical virtuoso, a magician with color and fully aware of the potential of watercolor, he was almost as devoted to it as he was to oil painting. Contrary to the then-current school of thought, which deemed that a watercolor should remain purely a doodle or a sketch and not attempt to rival oil painting, he persevered with the medium and managed to push it to its limits, but without distorting its true nature.

Because watercolor is in its very essence a transparent medium, free from impasto and intolerant of any reworking or retouching, Moreau was obliged to, and did, avoid what he was sometimes justly criticized for in his oil paintings: overemphatic decoration, excessive richness of paint and glaze, and fussy detail. And if, to heighten the brilliance and coloring of a work, he would sometimes embellish it with gouache and gold, he almost always used these with restraint, and he only rarely made the mistake of making miniature oil paintings of his watercolors, even when making copies of his own works.

1
THE GARDEN OF MADAME AUPICK, MOTHER OF BAUDELAIRE

Watercolor. C. 1864. 18 × 25.5 cm. Bottom right: *Gustave Moreau Honfleur / Jardin de Madame Aupick / mère de Baudelaire / vu du jardin de mon oncle*. Gustave Moreau Museum, Paris

After the death in 1857 of General Aupick, Baudelaire's hated stepfather, Madame Aupick retired to a house at Honfleur called the Maison Joujou, where Baudelaire often stayed and wrote poetry. One of Moreau's uncles had a house next door, and it was from there that Moreau painted this fresh watercolor, which shows the flower-covered wall that separated the two properties. In the background is a view of the broad estuary of the Seine. Gustave Moreau was fond of Baudelaire's poetry (which was unusual for the period), and Madame Aupick presented him with a posthumous edition of the *Fleurs du mal*.

His oil paintings frequently took him several months, even years of work; indeed he never finished the largest ones. It took him only a few hours to make a watercolor, and he himself was aware that the result was sometimes better. "It's odd," he declared, "the little watercolor I did today showed admirably how my work turns out best when I just run it off quickly."

He once called himself "ouvrier assembleur de rêves"—a dream builder. The phrase is appropriate and correct in the sense that it associates the builder, possessed of skill and a steady hand, with the visionary. It would be tempting to maintain, without stretching the truth, that it is through his watercolors that Moreau best managed to transcribe his dreams and fantasies spontaneously. As Marcel Proust wrote, "His vision continues to be seen, it remains before us, and that is what matters."

In this book about his watercolors we have tried, through a very broad selection, to give a full picture of Moreau's talent and sources of inspiration, considering not just the artist himself but also his relationship to his predecessors, to the literary and artistic trends of his time, and to posterity. A complex painter who thought deeply about the finite nature of art, he wanted to convey a message to the spectator and make his work a kind of bond, a term of recognition, between its creator and those who saw it—which is in fact the meaning of the word "symbol." He did not always succeed in this, and he himself was the first to fend off accusations concerning the esoteric nature of his paintings. "All you have to do is love and dream a little and not be content with a work that springs purely from the imagination, purporting to have the virtues of simplicity, lucidity or just silly childishness," he wrote to an admirer dismayed by the complexity of one of his works. It will be seen that it was surely in watercolor that he was best able to avoid the risks of being obscure, risks to which painters who think too deeply sometimes expose themselves.

A book devoted to watercolors may reproduce the works in more or less their true size. Thus the reader will have before him faithful reflections of the originals which, due to their extreme fragility, are usually hidden away in boxes in the print departments of museums, or else are in private collections.

2
THE YOUNG MAN AND DEATH

Watercolor with gouache highlights over pencil and brown-ink drawing. 1881. 36.1 × 22.7 cm. Signed bottom right: *Gustave Moreau*. Cabinet des Dessins (Hayem Bequest), Musée du Louvre, Paris

The Young Man and Death is an homage to Théodore Chassériau. Although he died at the age of thirty-seven, he had been Moreau's true master, and Moreau had rented a studio close to his near the Place Pigalle. Moreau worked for nearly ten years on this allegorical composition which he dedicated to Chassériau's memory. He shows the artist idealized as a young man, crossing the threshold of immortality, crowning himself with laurels. Symbols of death abound, but they are not macabre: Fate is a lovely young woman sleeping, holding a sword and an hourglass; the little putto holds a flame that is not yet extinguished; and the Hero has a bunch of jonquils, the flowers of Persephone, in his hand.

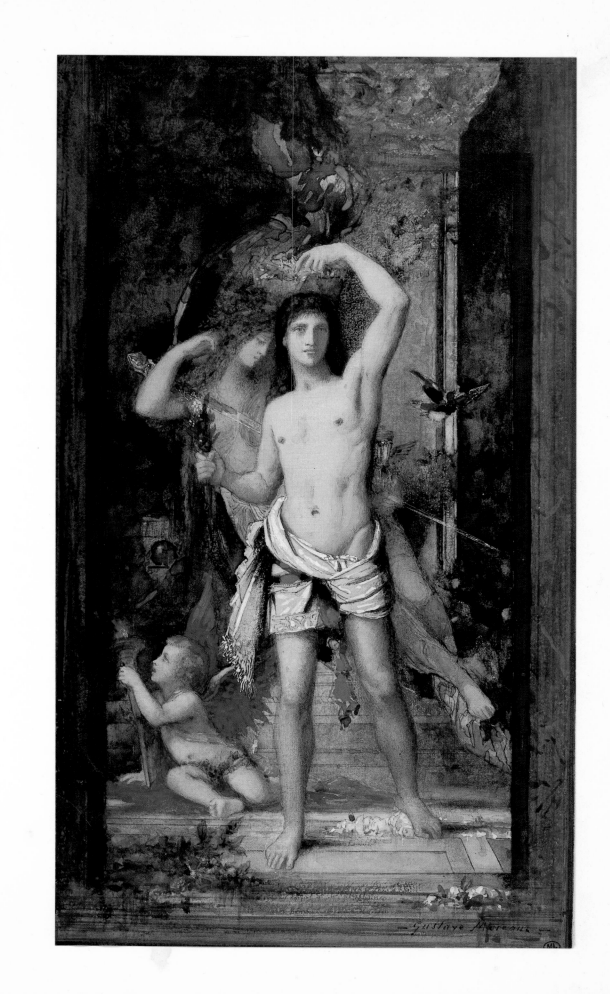

Chapter I A Strange, Indefinable Oeuvre

Two Aspects of Moreau's Art

Virtually all of Gustave Moreau's oeuvre, from the roughest sketches to the most highly finished paintings, is preserved. The circumstances leading to this unusual and fortunate situation begin with Moreau's parents, who from the very start encouraged his desire to become a painter, and who actively helped him to do so. Through them he had the good fortune to live from 1853 until his death in 1898 in a small townhouse in the rue Rochefoucauld, in the heart of the liveliest and most artistic quarter of nineteenth-century Paris, nicknamed New Athens. Many of his most brilliant contemporaries also resided there: Delacroix, Manet, Degas, Puvis de Chavannes, Thiers, Hugo, Renan, Alexandre Dumas (fils), George Sand, Zola, Chopin, Bizet, Berlioz, and so on. (Demimondaines and prostitutes also frequented the area.)

It was in this house, now the Gustave Moreau Museum, that the painter created his work, the greater part of which he bequeathed to the French state. In order to ensure that his gift would be accepted he had several large exhibition galleries built above his house. These were designed to contain the paintings, watercolors, and drawings that he had never wanted to show while he was alive: his studio had been a private and secret place. Even so, the authorities delayed for several years before accepting the gift.

Thanks to the devotion of Henri Rupp, the executor of Moreau's will, who gave up his own part of the bequest to pay for the necessary staff, the Moreau Museum was able to accommodate around 1,300 paintings, watercolors, and sketches as well as some 5,000 drawings. The remainder, another 6,000 to 7,000 drawings and small sketches, was stored in boxes at the museum. The extraordinary size of his oeuvre was surpassed only by that of the great British painter J. M. W. Turner, who, like Moreau, was a prodigious watercolorist. He too bequeathed all his work to the state.

The idea of gathering the greater part of his work in a special museum had come to Moreau at an early age; at that date it was a most unusual scheme, which explains the reticence of a state as yet unaccustomed to the idea of a painter offering a museum exclusively for his own work. On one of his small drawings he wrote: "Tonight, December 24, 1862 [he was thirty-six and had recently lost

3
FAIRY WITH GRIFFONS

Watercolor with gouache highlights. C. 1876. 24 × 16.5 cm. Signed bottom left: *Gustave Moreau*. Gustave Moreau Museum, Paris

This is one of Moreau's most seductive watercolors. It shows a little fairy seated casually, deep in her grotto, beautiful and untouchable, guarded by two griffons whose task it is to protect her from any brusque intrusion. At her feet is a chimera, half serpent, half woman, which provided above all an excuse to create a swirl of color. The Moreau Museum also has a large painting of the same subject, but it is more stiff and academic. André Breton, when he visited the museum at the age of sixteen, was awakened to an awareness of women. Some fifty years later he admitted that he had "always dreamed of breaking in one night with a lantern and surprising the fairy with the griffons in the darkness."

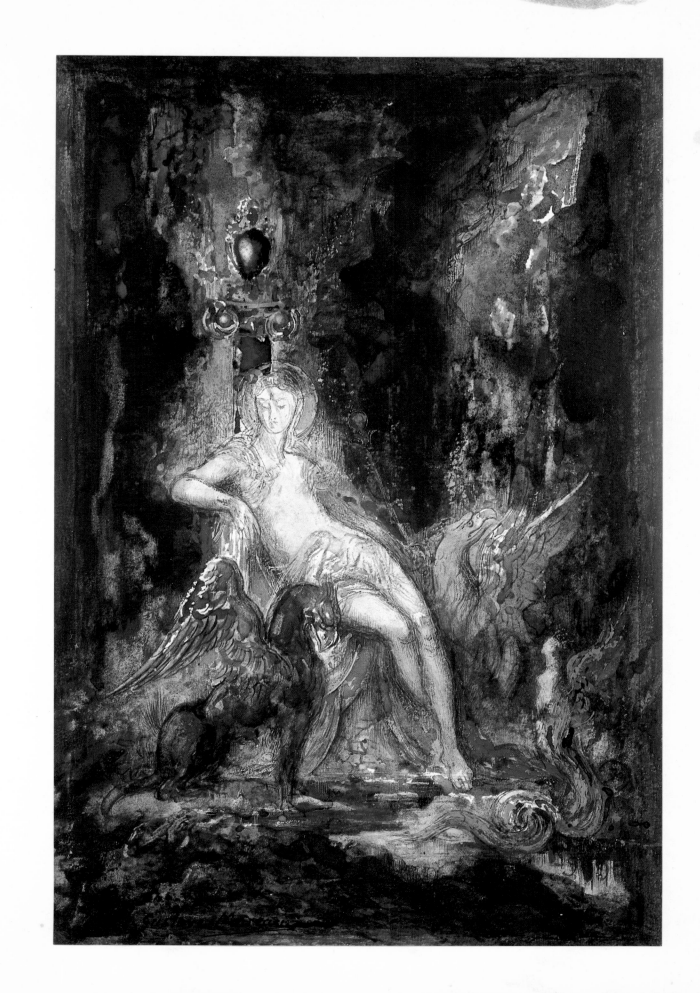

his father], I am thinking of my death and of the fate of my poor little works, all of those compositions I have struggled to keep together. Scattered, they will perish; seen together, they will give some idea of the sort of artist I was and of how I used to dream." For a man in his thirties, already haunted by the idea of death (which was one of his main sources of inspiration), it was strange to have been so concerned with posterity, especially as he was not yet at all well known; his first success, *Oedipus and the Sphinx,* dates from 1864.

Right up to his death he kept in his studio everything unsold that he had ever painted or drawn, consenting only grudgingly to sell his paintings or watercolors and declaring in his most personal writings, "I am so fond of my work that I will be happy only when I can do it solely for myself." However, Moreau became a successful painter, even if he was never truly popular: a sort of Balthus of his day, much esteemed in intellectual circles. All the works he exhibited at the yearly Salon, where he showed only intermittently, were widely reported by the press, which either praised him to the skies or violently criticized him, but rarely remained indifferent. Highly sensitive and intensely proud, he ceased to exhibit at the Salon after 1880 and seemed to withdraw from public life. But this did not prevent him from presenting himself, much to the surprise of his contemporaries, as a candidate for the Académie des Beaux-Arts (to which he was elected, at the second attempt, by a majority of one) or from accepting, at the age of sixty-six, a teaching post at the Ecole des Beaux-Arts in Paris. He was to be the last great teacher there, with pupils like Rouault, Matisse, Marquet, and Manguin, who venerated him and praised his teaching abilities to such an extent that André Breton and Salvador Dali reproached them for having forgotten that their master was also a talented artist. To repair this injustice, in 1970 Dali chose the Gustave Moreau Museum as the place to announce his intention to set up a personal museum at Figueras, which he would give to the Spanish nation after his death.

During his lifetime Moreau sold around four hundred works, and for fairly high prices, to his devoted supporters, most of whom he knew and who lived in the elegant Faubourg Saint-Germain. (Many of these works were exhibited together after the painter's death, in 1906, on the initiative of two prominent members of the nobility, Countess Greffulhe, immortalized by Proust as the Duchesse de Guermantes, and the Count de Montesquiou-Fezensac, also to be found in *Remembrance of Things Past* as the less agreeable figure of Baron Charlus, and the model for the hero of Huysmans's *A Rebours*.) One after the other, those people who were coming to be known as "snobs" were struck by the work of Moreau. Huysmans, one of his greatest admirers, described him as "a mystic trapped in the middle of Paris" and imagined him, perhaps exaggeratedly, to be "reveling in ecstasy, seeing magical visions, the crimson glories of the past."

Although an important group of Moreau's works, formerly in private hands, has since been acquired by various museums, public collections that can boast

4
TWO MODERN HORSEWOMEN (enlarged)

Watercolor. C. 1852. 16×21 cm. Signed bottom left in yellow: *Gustave Moreau.* Private Collection

From the start Moreau had a great passion for horses and drew them with pleasure. As a young man he went to the races, where he made numerous sketches in the style of Alfred de Dreux. De Dreux had been encouraged by his uncle, the painter Dedreux-Dorcy, to paint horses and their trappings. It was to Dedreux-Dorcy that Moreau's father showed his son's earliest efforts. This watercolor, one of Moreau's first, is similar to those by Géricault, whose work Dedreux-Dorcy collected assiduously. Here the young Moreau shows his mastery of watercolor. This scene of the elegant society of Paris under the Second Empire is one of Moreau's few works to depict contemporary life. Around 1850 Moreau was something of a dandy. He frequented elegant circles and went often to the opera.

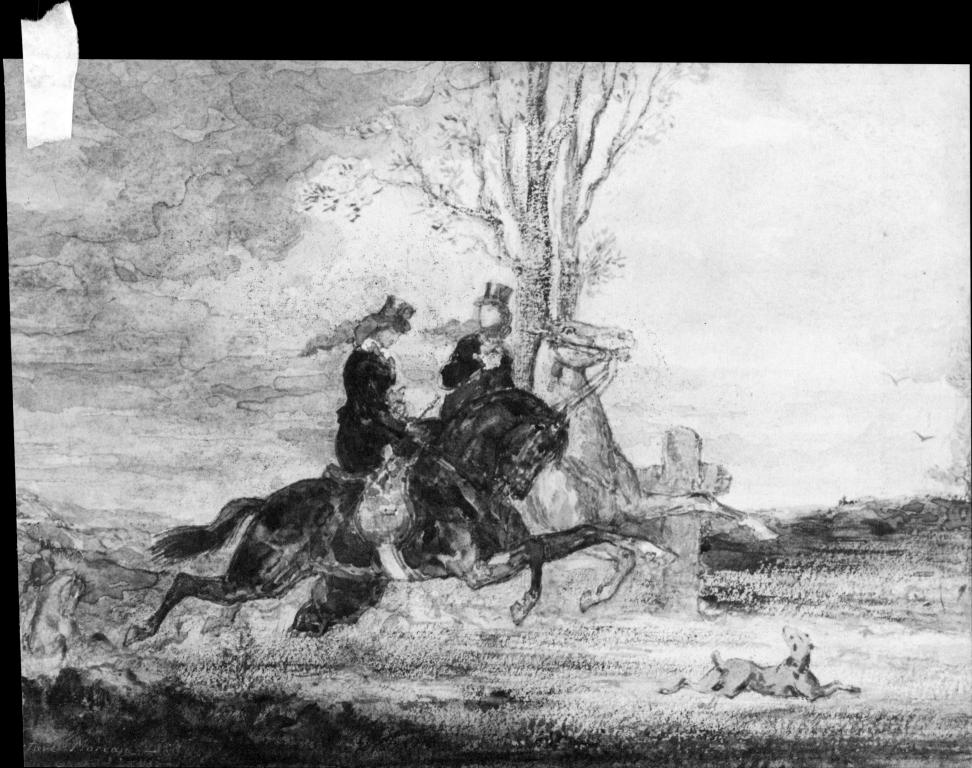

more than one or two are rare. Even the uninitiated are struck by the enormous difference in technique and style between the works Moreau exhibited, or parted with, during his lifetime (highly finished and intensely worked to the point of appearing like enamels) and the works in the Moreau Museum, to the extent that one would be justified in wondering whether they were by the same hand.

Such a dichotomy is, as far as we know, unique in the history of art, and reflects the artist's own inner conflict. He wanted to impress the contemporary public with his knowledge of artistic conventions, which he respected up to a point, while leaving for posterity his most intimate and ambitious works. He himself wrote:

> It must never be forgotten that I am a Frenchman and, in the true French fashion, I have never been allowed to follow the paths of fantasies and dreams and the search for the extraordinary without being attacked. Along this road, flanked by precipices, full of stakes and potholes, I have always heard, close to my ear, the sober, balanced voice of criticism, which made me question everything I really felt and which told me that my fantasies were on the verge of stupidity and folly. So it is very difficult, not to say impossible, to be able to appreciate what an artist would be able to do if left to, or even encouraged in, his artistic endeavors.

Moreau's oeuvre, like the painter himself, is full of contradictions. These will be analyzed in the text that follows, not in order to explain his mysteries, but in an attempt to understand his motivations.

The History Painter

Moreau himself had wanted to be a history painter, following in the footsteps of Delacroix and, especially, Chassériau, whose grand mural decorations he greatly admired. His education at the Ecole des Beaux-Arts, under the rather dreary guidance of François-Edouard Picot, a follower of the Neoclassical school and pupil of François André Vincent and David, had encouraged him in this genre, which the hierarchy of academic taste placed well above landscape, portrait, and still-life painting. It is perhaps useful to remember that history painting at that time only comprised certain biblical subjects, scenes from classical history, mythology, or the lives of the saints. The model *par excellence* was Poussin, whom Moreau emulated. After spending two years in Italy, from 1857 to 1859, he attempted to model his career on that of Poussin, whose prestige was formidable during the nineteenth century. Did not Cézanne, at the end of his life, want "to recreate the work of Poussin after nature"?

It was customary for history painters to use heroic and didactic subject matter, preferably on a large scale. In Italy Moreau studied closely the great fresco

5
HESIOD AND THE MUSE

Black chalk and brown ink with white gouache highlights on beige paper. 1858. 37.7 × 29 cm. Bottom left: monogram *GM Gustave Moreau Rome 1858*. National Gallery of Canada, Ottawa

During his two-year stay in Italy Moreau made copies after the Old Masters and did some landscapes but produced hardly any original works. This beautiful highlighted drawing and another of the same subject (private collection, New York) are exceptions. This is the first in a long series of works dedicated to poets and the Muses, and especially to Hesiod, the Greek poet of the eighth century B.C., who described himself as a shepherd. One day Hesiod was visited by the Muses, who inspired him to write the *Theogony* and offered him a branch of laurel. This drawing, Neoclassical in style and design, is like an illustration of the theme "Let Painting be Poetry" *(Ut pictura poesis)*. We know that Moreau drew his inspiration from reading Hesiod, Virgil, Homer, and Ovid. A highly cultivated man, he possessed some 1,600 volumes in his library.

16

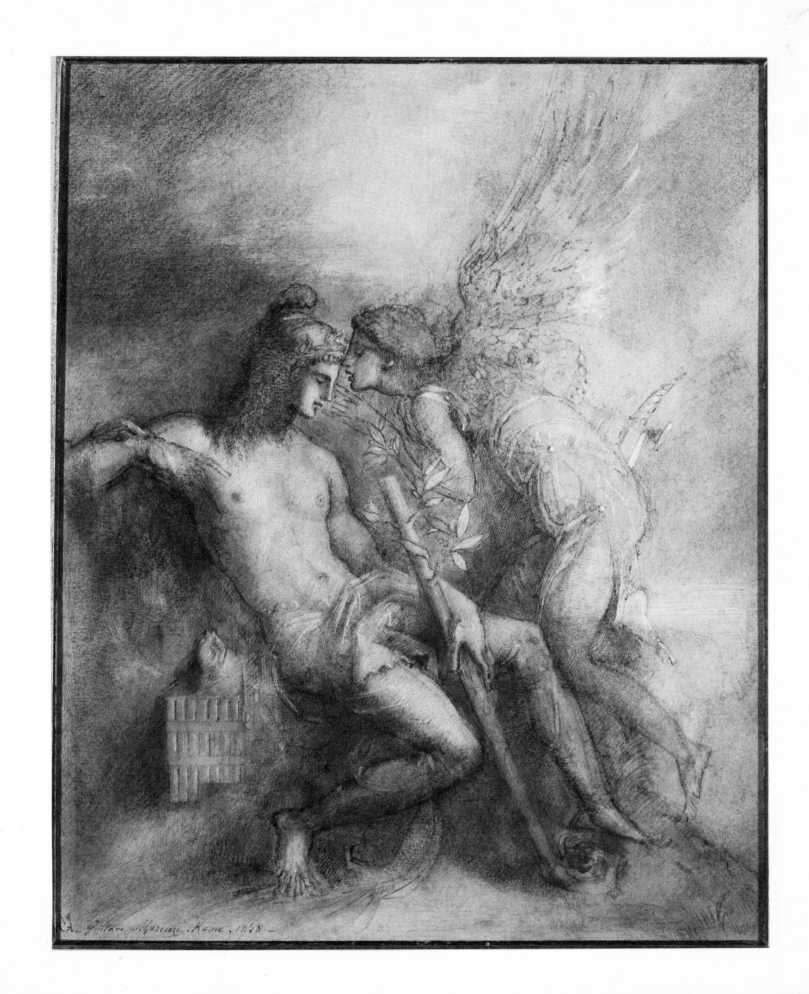

painters of the Renaissance. He examined Mantegna, Michelangelo, Raphael, Sodoma, Luini, Gozzoli, and Andrea del Sarto, as well as ancient Roman painting in Naples. But, in spite of Moreau's originality, all the subjects he tackled had already been illustrated by previous history painters. The genre was already exhausted by the mid-nineteenth century and would not survive much longer.

There is a part of Moreau's oeuvre that is a testament to the failure of his ambitions. Between 1850 and 1860 he undertook a series of large canvases with subjects such as *Tyrtaeus Singing during Battle, The Suitors, The Daughters of Thespius,* and *The Adoration of the Magi,* which he worked on sporadically for the rest of his life but never finished. Having built a large gallery in which to show them, he was determined to complete them, as proof to future generations of his deep vocation. But such works were too ambitious, and only when he turned to smaller-scale paintings and watercolors was he successful. Perhaps we should not take too much notice of the comment he made—no doubt sincerely—after refusing in 1874 to decorate the chapel of the Virgin at the Panthéon: "[The commission arrived] fifteen years too late; for after returning from Italy I saw that there was no hope of receiving the commissions I felt to be most important. I knew I had to change my style and restrain my technique. I told him [the director of the Ecole des Beaux-Arts] that it was partly for his benefit that I was striving to prevent the disappearance of history painting, which was no longer found except in frescoes and in the decoration of public buildings, but not in smaller paintings."

There were certain subjects of history painting that obsessed Moreau. These he treated in his own way, imbuing them with his fantasies, achieving a highly personal symbolism, and turning his back on historical truth, unlike his contemporaries who tried to reconstruct historical scenes as accurately as possible. "The great legends of antiquity," he wrote, "should not be constantly transcribed as history, but as eternal poetry. Ultimately one must leave behind the schoolboy's lists of dates, for these constrain the artist to show a particular point in time, instead of creating great poetry. Not a factual but a spiritual time-scale. The intensity of myths should not be restrained by chaining them to an era or to the models and styles of that era."

Moreau believed that it was the responsibility of painters (and indeed of poets, with whom he felt a great affinity) to elevate the soul of the spectator and to communicate a message—as would a philosopher or priest—by means of style and color. "How wonderful for the painter—sublime and wise inventor, divine creator—who was the first to discover the eternal eloquence of this mute language which showed that everyone can relate to this language of myths and symbols. Oh, noble language of impassioned silence, that art which, as a tangible rendering of physical beauty, reflects great flights of the spirit, soul, heart, and imagination, and fulfils the spiritual needs of generations. It is the language of God."

18

6

THE UNFAITHFUL HANDMAIDENS

Red chalk with white chalk highlights on gray paper. 1856. 44 × 29.1 cm. Signed bottom left: *Gustave Moreau;* bottom right: *Suivantes Infidèles;* notes at the right: *œil plus | sur le côté | le bras | droit | juste.* Gustave Moreau Museum, Paris

While he was working on *The Suitors,* Moreau began work on another composition, *The Unfaithful Handmaidens,* which was to illustrate the next episode in the story of Ulysses: the cruel fate of the servants who had been too indulgent to Penelope's suitors. From this project there remains a series of small red chalk studies that show scenes of panic. This one is particularly interesting because Moreau made several sketches of arms and torsos for the same woman on a single sheet, a procedure frequently adopted by Ingres.

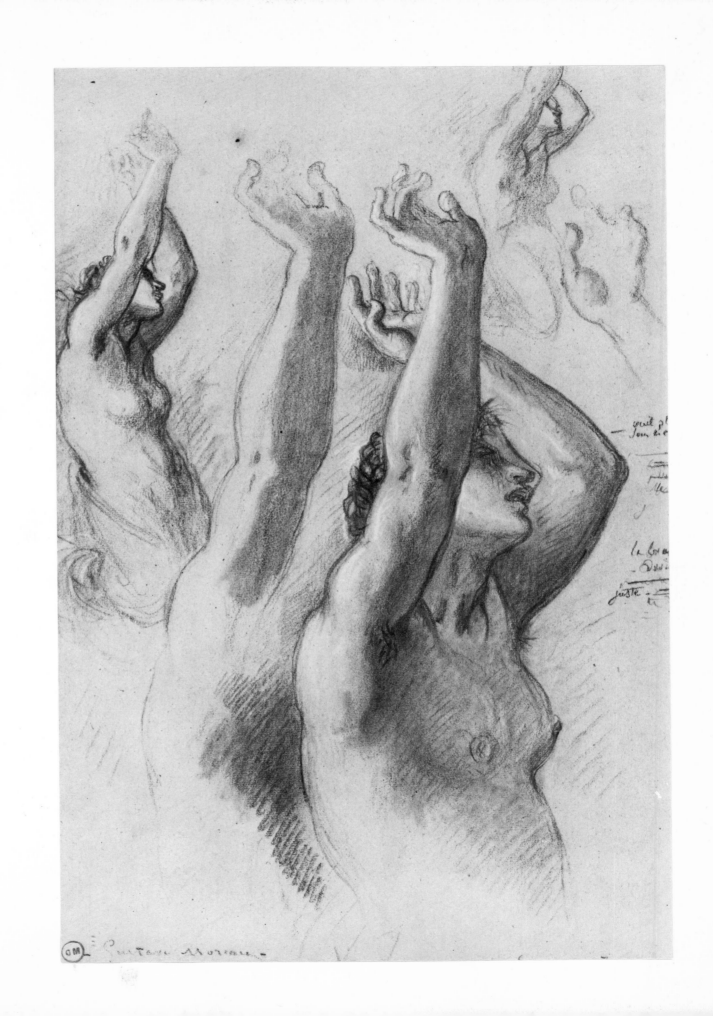

By adopting the Neo-Platonic theories popular during the Renaissance, Moreau ran the risk of overloading his paintings with ideas and allusions. While he was able to avoid being adopted by Péladan as a herald of idealistic painting, at the very center of the Rosicrucian movement, still he had a tendency to make his works so erudite and allegorical that their meaning was obscured unless they were accompanied by an explanation. Although Moreau and his contemporaries were far more familiar with classical culture and mythology than people are today, and enjoyed that sort of literature (oddly enough, in this respect Moreau resembles Flaubert in his *Temptation of Saint Anthony* and in *Salammbô*), a large section of the public was unable to appreciate his work. While he resented being called a literary painter, as he often was, he in fact spent the last months of his life writing about the paintings which, after his death, were to fill his museum.

The Neoclassical Tradition

The Ecole des Beaux-Arts, when Gustave Moreau was a student there in the 1840s, taught its pupils according to the well-established formulas of the schools of David and Ingres, thus favoring draftsmanship over colorism, and striving for the formal perfection that reveals complete mastery of the brush. Moreau's taste was also influenced by his father, architectural overseer for the city of Paris, a highly cultured man, a great admirer of the Age of the Enlightenment, and author of a project to reform the Ecole des Beaux-Arts, which he submitted to David and, later, to the government of Louis-Philippe. The aim of the report was to broaden the education of artists to include many disciplines, as in the Renaissance. "Everyone," Moreau told his pupils, "should have a father like mine—wealthy, meticulous in his work, an architect who had lived among artists, aware of the great difficulties of assessing a work of art, and who never imposed his own ideas on me." It was his father who prepared Moreau for his *baccalauréat* examinations and who sent him, at the age of fifteen, on his first trip to Italy, giving him an album with forty-five empty pages which he filled with sketches of what he saw. He also had access to his father's library and covered the pages of the huge tomes with hundreds of drawings. A great admirer of the ancient era, Moreau's father shared his generation's predilections for the civilizations of the past and owned many important works describing the discovery of classical antiquity: *The History of Ancient Art* by Winckelmann who, through Greek and Roman statuary, defined the criteria for the Neoclassical movement; the *Journeys of the Young Anacharsis* by the Abbé Barthélemy, whose seven volumes constituted an introduction to Greek civilization; *Antiquities of Athens* by Stuart and Revett, the first archaeological study of the Acropolis; an *Antiquarium statuorum urbis Romae,* which contained reproductions of the most important statues found in Rome; John Flaxman's engravings for the *Iliad,* the

7
AUTUMN or ERIGONE (enlarged)

Watercolor over pencil and brown-ink drawing. C. 1852. 21.5 × 16.5 cm. Bottom center: *Gustave Moreau Automne.* Gustave Moreau Museum, Paris

This freely executed watercolor recalls certain sketches by Delacroix, especially in the use of rapid hatching for the modeling. It is a preliminary study for a painting in the museum at Lille showing Erigone, a young Athenian girl whom Dionysius, seen as a child at her feet, introduces to wine and drunkenness. She squeezes a bunch of grapes in her hand, holding it like a severed head. Her face already shows the influence of alcohol. Her stance, with the folded leg, is influenced by Michelangelo's *ignudi* on the Sistine ceiling.

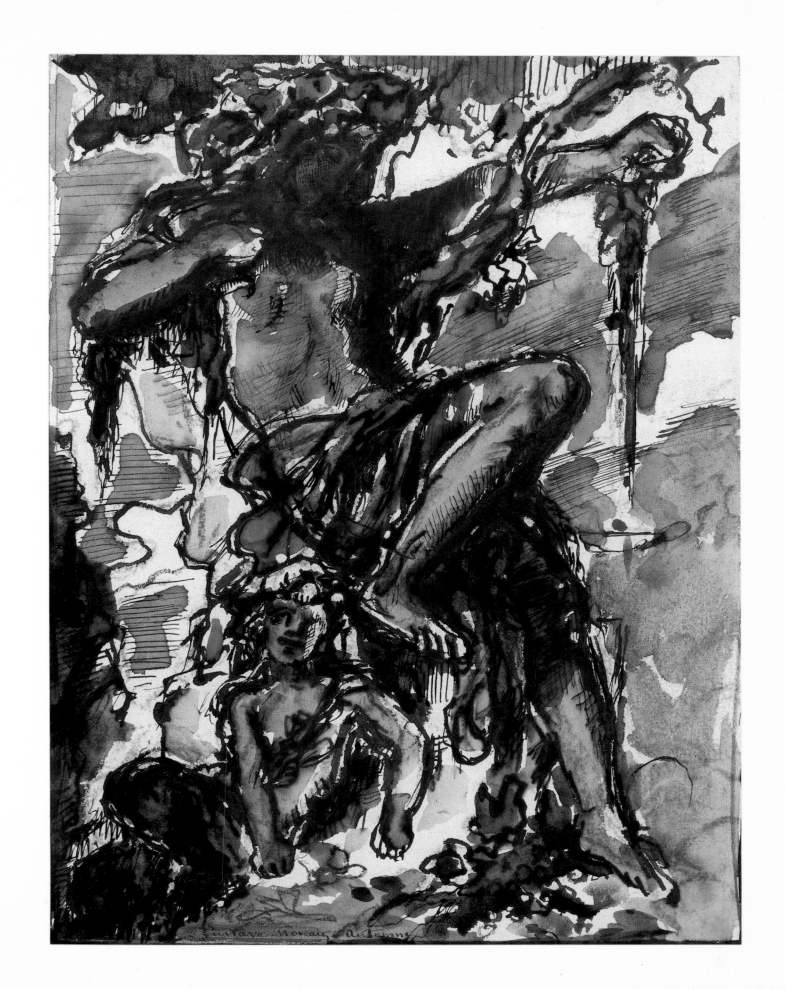

Odyssey, the tragedies of Aeschylus, Hesiod's *Theogony,* and Dante's *Divine Comedy,* which the elder Moreau gave to Gustave in his tenth year, and not least a large, lavishly illustrated, seventeenth-century edition of Ovid's *Metamorphoses.* Of this last work Moreau said when working on his great watercolor of Phaeton: "It is thirty-five years since I first read that superb passage in Ovid and, without a shadow of doubt, it stimulated my imagination to the extent that I can still recite it almost word for word, and its inspiration has never left me. Let this be a lesson to those who believe that one must actually be reading about something in order to represent it adequately."

All this reading, this familiarity at an early age with the antique, left its mark on Gustave Moreau and equipped him, well before he started at the Ecole des Beaux-Arts, with a range of images and subjects that he was to use throughout his career. The teaching he received, based above all on drawing, and his familiarity with the excellent draftsman Chassériau, one of Ingres's most gifted pupils, crystallized his working methods. As with the followers of David, his passion for antiquity was soon matched by a keen interest in the Italian primitives; in them the painters and art historians of the first half of the nineteenth century found a purity equal to that of the masterpieces of Greek art. Moreau studied them closely during his stay in Italy, from the Campo Santo at Pisa to Santa Maria Novella in Florence. After 1862, when the famous Campana collection of Italian primitives was shown in Paris, no other painter copied so assiduously and copiously the hundreds of works in the exhibition.

Stylistically, Gustave Moreau's drawings are Neoclassical. He attached great importance to the study of the nude—fundamental to classical painting—and to the quest for good style, as defined by the academic canon in the first half of the nineteenth century. However, because color plays such an important role in Moreau's paintings, his talents as a draftsman have long been ignored, just as the importance of draftsmanship for Delacroix has been underestimated, or the use of color for Ingres. To be sure, unlike Ingres or Degas, Moreau was not a born draftsman, but he did leave some important drawings. Any visitor to the Moreau Museum, looking through his thousands of drawings, quickly realizes not only that drawing played a crucial role in Moreau's artistic vocabulary, but also that the artist (whose youthful drawings could be taken for Chassériau's) was a first-rate draftsman, diverse and often surprising. He handled many different techniques with equal skill—lead point, red chalk, pen and ink, charcoal, black chalk—sometimes combining them in order to realize his vision. He transferred the finished drawing, refined through the use of squared sheets and various sketches, onto the final work. This long series of operations, far less complex in his watercolors, unfortunately caused Moreau's drawings to become far more rigid than his more natural and attractive early sketches. Ingres, in contrast, usually began with awkward, poorly drawn sketches and gradually built up to the grandeur of the broad, smooth lines that distinguish his finished drawings.

8
THE PERI

Watercolor highlighted with gold over pencil drawing. 1865. 51 × 46 cm. Bottom from left to right: monogram *GM Dessin pour email LA PÉRI Gustave Moreau Inv. et Pinx.* The words *LA PÉRI* are in gold letters. Cabinet des Dessins (Hayem Bequest), Musée du Louvre, Paris

This exquisitely detailed watercolor was made as a model for an enamel which Moreau had made by his studio companion, Frédéric de Courcy, who during the 1860s tried to revive the technique of enamel painting. This is one of Moreau's first forays into the exotic world of Eastern legend. It is very highly worked, as if he wished to emulate the rich coloring of the Persian miniatures he so greatly admired.

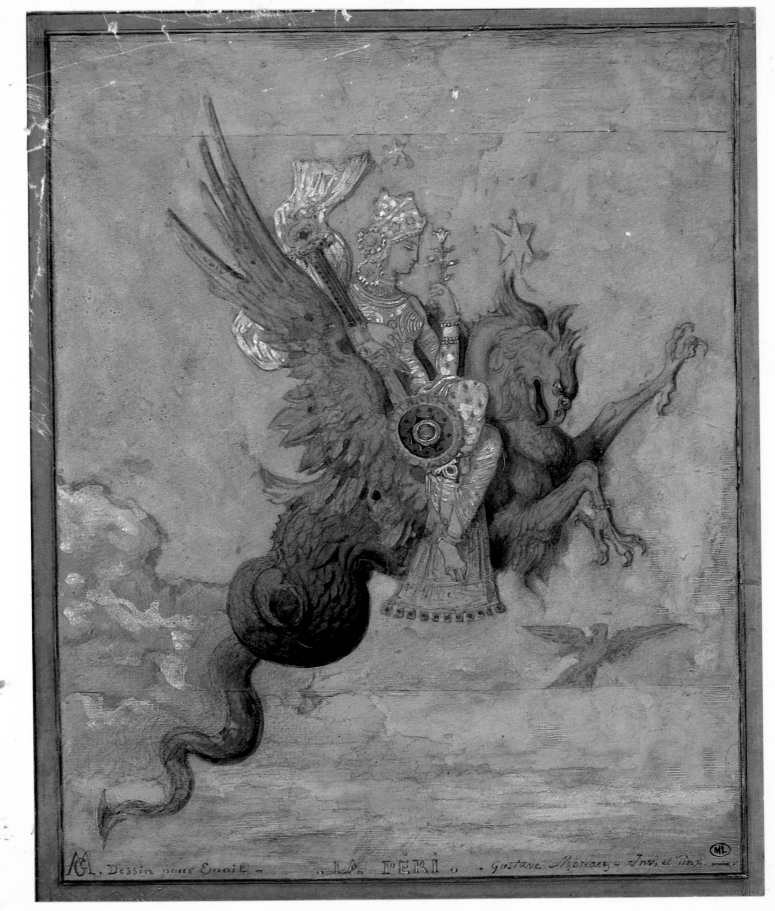

AG. Dessin pour Email . LA PÉRI . Gustave Moreau. Inv. et Pinx.

Neoclassical aesthetics imposed on the human form precise norms which, it was believed, stemmed from a Greek ideal of sensuality and smoothness. In fact this ideal existed only in the imagination of artists and historians of the nineteenth century. Moreau, like Ernest Renan (whose son, Ary, was the artist's first biographer), believed in this Greek miracle—a place where perfection had existed, where precise laws governed proportion and behavior, where faces, usually seen in profile, had the "Greek nose" descending in a straight line from the forehead, where the pursuit of ideal forms required that the lines of the male body, usually youthful rather than mature, should be smoothed out, and where the importance of drapery and clothing was more to emphasize the forms of the body than to cover them. It was this academic aesthetic that led Moreau to choose for his pictures scenes that were generally calm, contemplative and without action, so that the human body could be shown in a way that emphasized its sculptural beauty.

The quest for this kind of beauty, itself a source of inspiration, could be compared in literary terms with the aims of the contemporary Parnassian poets, Symbolists who strove for a truly pure poetic form, free from modern preoccupations, and sought refuge in a mythological past where emotion was restrained. Without laboring the comparison between poetry and painting, one may point out close ties between Moreau and certain writers connected with the Parnassian movement: José María de Heredia, Théodore de Banville, Mallarmé, and Henri Cazalis. And later, his paintings inspired the poetry of Henri de Régnier, Jules Laforgue, Albert Samain, Pierre Louÿs, and Jean Lorrain. Each of them could have spoken the words that Moreau wrote about his repugnance for overwrought, violent art: "I cannot accept spontaneous emotion; it exists, but I reject it as being useless and base in art. I only recognize reasoned emotion, which forces one to return to that art which is restrained and measured. Such emotion is forged with real sensitivity and with unshakable regard for the expression of true, eternal beauty."

The cult of the perfection of the human body even led Moreau to increase the number of unnecessary figures in his paintings simply for the sake of their beauty, and he attached great importance to them. This type of immobile figure can be seen in *Tyrtaeus, The Suitors, The Return of the Argonauts,* and *Salome.* To justify this, Moreau once explained the purpose of such a figure isolated in the middle of the painting *The Suitors:*

> I am dominated by one thing: the greatest passion and drive toward abstraction. The expression of human feelings, of men's passions, naturally interests me greatly, but I am less inclined to express these transports of the spirit and soul than to render visible (so to speak) the deep, internal glimmerings which are difficult to pin down and which possess something of the divine in their apparent insignificance and which, transcribed in a wonderful, purely visual way, open up horizons that seem enchanted, even

9
DREAM OF THE ORIENT

Watercolor highlighted with gouache. 1881. 29 × 17 cm. Signed bottom left in red: *Gustave Moreau.* Private Collection

A comparison between this ravishing watercolor and *The Peri* of 1865 shows how Moreau's work developed over fifteen years. The crisp, rather tight drawing of *The Peri* has softened considerably, and the design has become more relaxed. This is a truly magical vision of the Orient, a fireworks display of sparkling colors over the blue tones of the landscape and sky.

divine.... It is only in these instants that the artist becomes sublime; he forgets the vulgar physical manifestations of nature to abandon himself completely to that of dreams, of the intangible. To make myself clearer, I do not mind admitting that the face of the Mona Lisa or an Indian god are worth all passions, all defined human feelings.

It was Erwin Panofsky who noticed in Michelangelo's work the "movement without locomotion" characteristic of his figures and saw in this a projection of the inner self of the artist, whose homosexual tendencies and desire for solitude are well known. The question of Moreau's sexuality will be discussed later, but he, too, had a deep horror of promiscuity. At Moreau's funeral Degas remarked that "he was one of those men who would always shuffle back to prevent anyone stepping on his feet." There are clear examples in Moreau's work of this "movement without locomotion." Long before Panofsky, the painter was struck by the mystery of Michelangelo's figures, to the extent of writing a page about them that could almost have been written by Malraux:

> All Michelangelo's figures seem to be frozen like idealized sleepwalkers, almost unaware of their motion in the composition as a whole. To find the reason for this constant repetition of the dreamlike quality of his figures.... What are they doing? What are they thinking? Where are they going? What feelings govern them...? People do not rest or act, walk or weep, or meditate or think like that on our planet, in our world. Gestures are always understandable in sculpture; in Michelangelo the expression, the outward gesture of the body, always conflicts with the feelings expressed, and vice versa (an extraordinary technical ability). He becomes two artists, expressing both Heaven and Earth.

From the Visible to the Imaginary

A general movement in nineteenth-century painting led an increasing number of artists to give an overriding emphasis to nature, to the extent of rejecting other sources of inspiration; Moreau seems to have moved against that current. Yet it would be wrong to ignore an interesting aspect of his work: his numerous landscape studies. They reveal a strong sensitivity to nature, a vision similar to Corot's, and an ability to capture the light and atmosphere of a place.

Especially in Rome, where he deliberately followed in Poussin's footsteps, Moreau recorded in sepia, pastel, and watercolor views of the eternal city and the Roman Campagna: the gardens of the Villa Borghese, the silhouette of the Colosseum seen through the leafy boughs of a park, the Ponte Nomentano, the Villa Pamphili, the ruins of the aqueducts, and the Aqua Acetosa fountain. Even at this early stage he had a preference for the hours around dusk, when the setting

10
ORPHEUS (enlarged)

Watercolor with highlights of gouache and gold. 1864. 21.5 × 13.5 cm. Bottom left: monogram *GM Gustave Moreau 1864*. Private Collection

Gustave Moreau showed his oil painting *Orpheus* at the Salon of 1866. It was purchased by the state and during his lifetime was his only work to be shown at the Musée du Luxembourg, the nineteenth-century's museum of modern art. In the catalogue of the Salon the painter summarized the subject as follows: "A young Thracian girl reverently carries Orpheus's head and lyre across the Hebron to the shores of Thrace." Moreau made several replicas of this famous painting. This watercolor (curiously dated the year before the oil painting) shows the girl with a golden halo. Marcel Proust claimed that he could perceive Moreau's soul in this work: "He looks at us through the blind eyes of pure color."

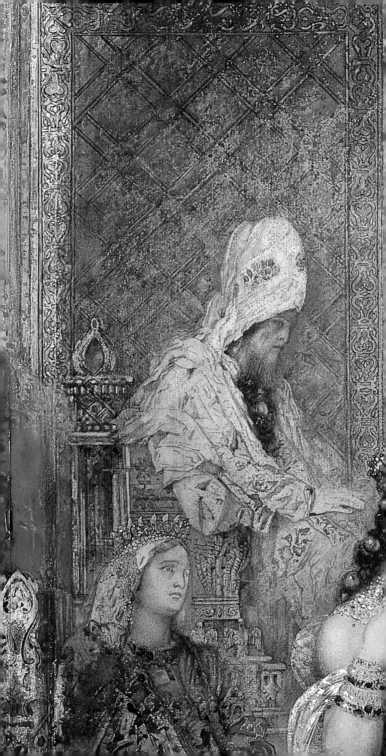

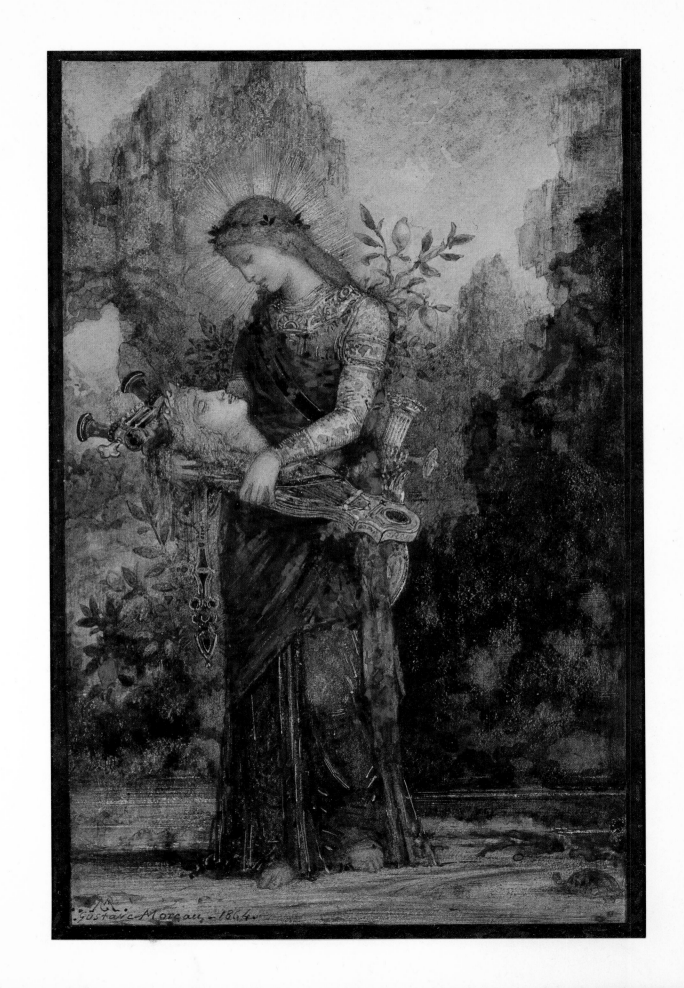

Gustave Moreau, 1864.

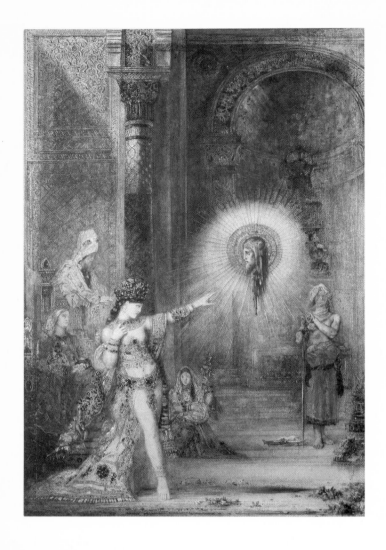

11

THE APPARITION

Watercolor. 1876. 106 × 72 cm. Signed bottom left in gold: *Gustave Moreau*. Cabinet des Dessins (Hayem Bequest), Musée du Louvre, Paris

It would be possible to mount a powerful exhibition on the theme of the beheading of Saint John the Baptist in painting and literature from the Middle Ages to the present day. But although artists before Moreau had already tackled this scene from the Gospels, none of them had thought to show the saint's severed head involved in a dialogue with his persecutor. Huysmans's description of the work is often quoted, but one hears less often of the mysterious verse written by Mallarmé in 1885, inspired by this watercolor, *The Canticle of Saint John:*

In the darkness of the night
The bones of my body shudder
As my severed head
Alone, ever on the watch,
Parts from my mortal frame,
All ancient discord set aside
By the fatal sword's clean sweep.

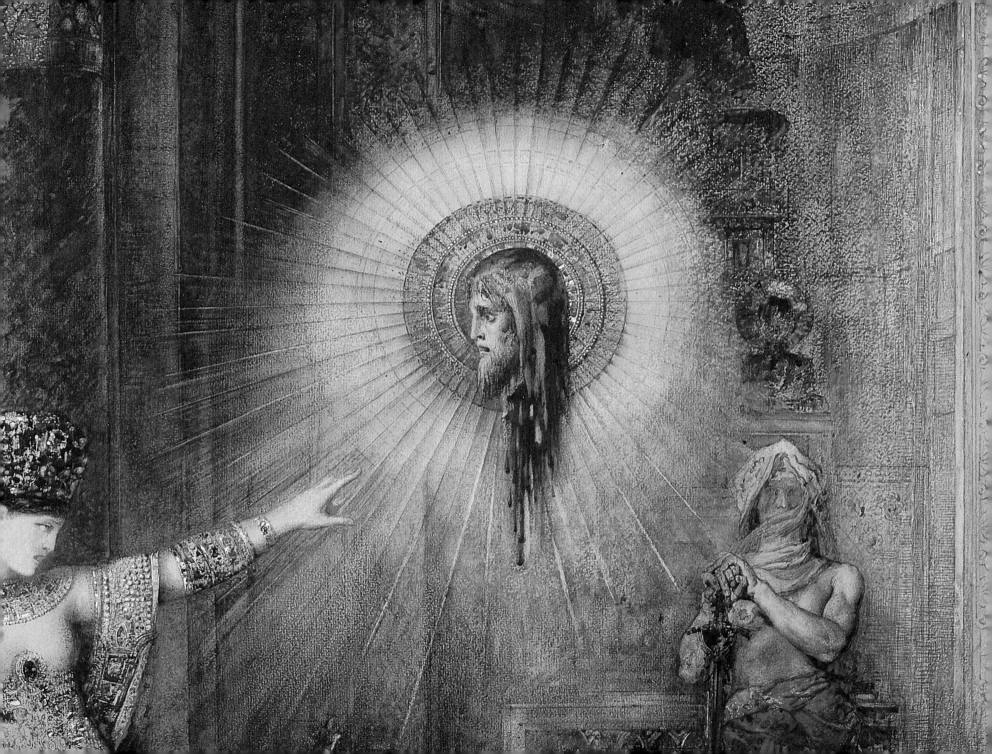

sun casts its roseate glow on the woods and waters. "Banks of the Tiber," he noted on a sepia wash, "April 20, 1858, 6 P.M., purple water streaked with steely blue and touched with deep yellow." He wrote to his parents regretting that the weather was not good enough for him to get out more often, adding: "I must succeed in filling this gap in my education, for I regard these studies as most important. I don't know where to begin. There is so much to learn, and, despite great efforts, one can never do as much as one had hoped." Yet it ought to be remembered that he preferred copying Old Masters to tramping through mountains and valleys, hunting for beautiful landscapes. Later on, back in France, he liked to wander around Etampes and the Juine valley, where his friend, the painter Berchère, came from, or else to spend time at Honfleur. One of his uncles had a house there, next to the famous Maison Joujou, which belonged to Baudelaire's mother and to which the poet retired after 1860. Moreau once made a watercolor on the bottom of which he noted: "The garden belonging to Mme Aupick, mother of Baudelaire." Did he know the poet? In any case he possessed his complete works, of which the first volume—which includes *Les Fleurs du mal*—was given him by Baudelaire's mother. It is known that he liked his poetry—to the surprise of Gustave Larroumet, a colleague of Moreau's at the Académie des Beaux-Arts and professor of literature at the Sorbonne, who was reproachful that he made "so much of Baudelaire, a strange and incomplete artist, an artificial character and a sick soul."

The paucity of paintings, watercolors, pastels, and drawings of nature, though they are often of good quality, suggests that Moreau was not particularly attracted to nature. According to Maurice Denis, Moreau himself was aware of having missed out on "ten years of nature." Moreover, when he became a teacher, he tended to send his pupils to museums and not out into the world.

Landscape, which appears frequently in his paintings and watercolors, was for him a tragic element, usually mountainous or barren, and he drew from Leonardo da Vinci more than from direct observation of nature. Unlike some of his close friends, such as Fromentin, Chassériau, or Berchère, who had all traveled widely in the East, Moreau preferred to listen, read, and dream. He even imagined writing a book about eastern travelers in which he would compare the accounts of Lamartine, Gautier, Fromentin, Maxime Du Camp, Chateaubriand, Jacquemont, and Gérard de Nerval, and he declared: "I am so involved in my dreams, my flights of imagination, that I approach all I read and hear about distant or extinct civilizations with naïvety, an impulsive, childlike credulity. How can one love, understand, or dream of India, of the forests of the New World, of the wondrous archipelagos of the eastern ocean and the antediluvian flora of central Africa, with cynicism or scepticism, or with a mind to pretentious and pompous debate?" In his library he had a complete set of the *Magasin pittoresque,* a popular weekly magazine full of illustrations, to which his father had subscribed since 1833, and where one could read articles about famous cities and places, reports by explorers, and ethnological studies, and he had

12
SALOME IN THE GARDEN

Watercolor. 1878. 72 × 43 cm. Signed bottom right in black highlighted with gold: *Gustave Moreau*. Private Collection

For a long time Gustave Moreau was obsessed by Salome, to the extent of showing her toying with her macabre trophy while out in a garden, seen here under an arbor of deep green taken from a painting by Mantegna. Moreau totally ignored the religious nature of the subject, treating it as if it were a myth, thus paving the way for the eccentricities of others such as Huysmans, Laforgue, Wilde, Beardsley, and Strauss.

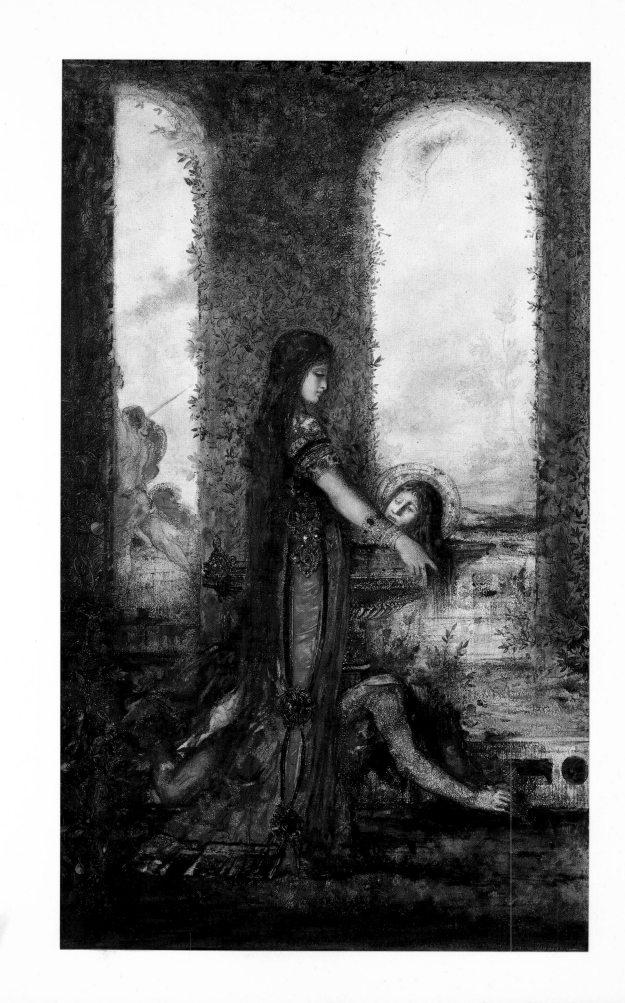

several volumes of the *Tour du monde* and *South Sea Travels* by MacCarthy, *Civilizations of India* by Gustave Le Bon, and other such works. It was from these often crude magazine illustrations that he would be able to form an image of Galatea's Cave, or the *Fairy with Griffons* or the Indian valley for the *Triumph of Alexander the Great,* or the mihrab of the Persian mosque where Salome danced.

Nobody understood or described better the mysterious world that Moreau created than the young Marcel Proust in an essay of around 1898 devoted to the painter:

> Moreau's landscapes are truly a place where a god or a vision might appear, and the reddening sky is a sure portent, a passing deer a favorable omen, and the mountains so sacred a place that next to it an ordinary landscape painting seems vulgar and meaningless, as if the mountains, the sky, the animals, and the flowers had in an instant been deprived of their very reason for being there, as if the sky and flowers and mountains no longer bore the marks of some portentous event, as if the light were no longer that in which gods could appear or courtesans be seen, as if nature, devoid of its intellectual meaning, had immediately become larger and more base. Moreau's landscapes are usually squeezed into a gorge or enclosed by a lake where a divine presence can often be felt, becoming immortalized on the canvas like the memory of some hero.

As time has passed, Moreau's paintings, often far too heavily worked, have lost much of their impact. It was in his watercolors, where it is not possible to rework and freeze the forms, that Moreau best translated his dusky, reclusive vision of nature, where the reddening sky colors the reflections in the waves near where Hercules encounters the snake-headed monster, or where the sun casts its dying light on Pasiphaë's body. Rarely has an artist managed to create landscapes that relate so intimately to the theme he painted. It was in these watercolors that he fully realized his theory that: "a true moment of passion and feeling can never be provided by the subject itself, or made entirely from nature." One might compare him to Turner who, faced with the setting sun or standing in the heart of the mountains, or on the banks of the Grand Canal in Venice, was also able to respond to the unshakable beauty of nature in his watercolors, to which those of Moreau seem hardly inferior.

13
WOMAN WITH A PANTHER

Watercolor. C. 1880. 29.5 × 19.5 cm. Gustave Moreau Museum, Paris

"An evocation in watercolor" one might call this rather strange interpretation of Salome, who stretches out her arms toward a platter on which one can make out the haloed head of Saint John the Baptist, while a black panther, symbol of luxury, frolics in front of her. With its large areas of white, its long streaks of transparent color in beautiful combinations of mauve, green, yellow, and blue, this is a particularly attractive work.

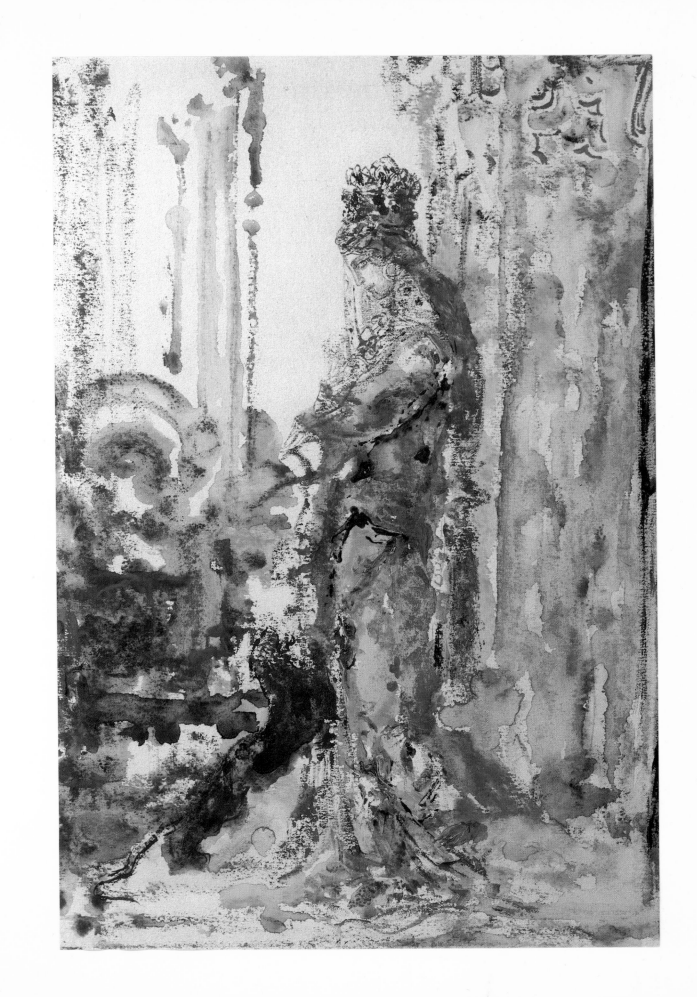

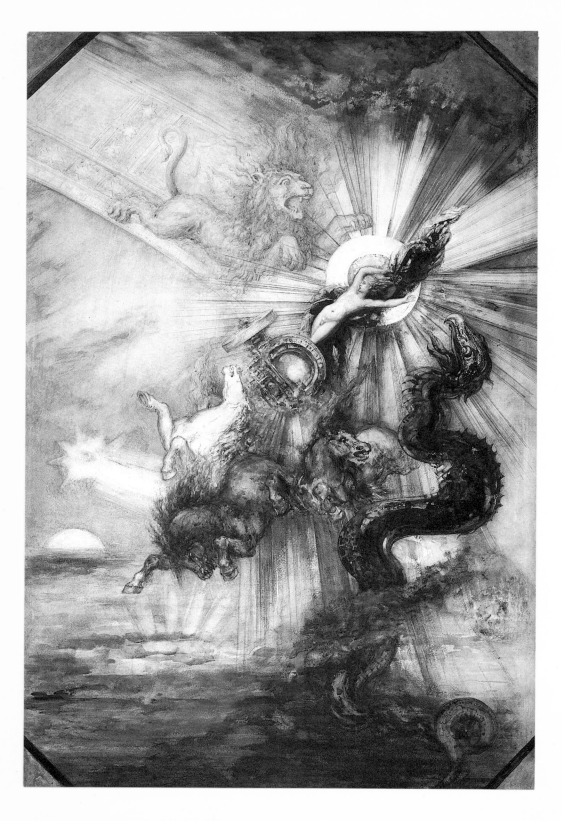

PHAETON

Watercolor with highlights of gouache and
varnish over pencil drawing. 1878.
99 × 65 cm. Signed bottom left in red:
Gustave Moreau. Cabinet des Dessins (Hayem
Bequest), Musée du Louvre, Paris

In this virtuoso piece, Moreau is consciously
emulating Delacroix's ceiling of the Galerie
d'Apollon in the Louvre, but Moreau's
project remained at the watercolor stage. The
composition, especially the horses viewed
from below, indicates that Moreau envisaged
the work as part of some decorative scheme.
The youthfulness of the son of Helios, the sun
god shown nude (which is exceptional in
Moreau's work), must have led him to
endow the body with the slender grace found
in most of Moreau's heroes.

The Last Romantic Painter

To whom could he turn when, in 1850, at the age of twenty-five and after two failures in the competition of the Prix de Rome, he still wished to continue in his vocation, yet felt that he would learn nothing from the Ecole des Beaux-Arts? Naturally the name of Delacroix springs to mind. Although Delacroix did not win the Prix de Rome he had managed to breathe life back into history painting, and he had had a magnificent career as a decorator, his last commission being for the Galerie d'Apollon at the Louvre. The young Moreau, who lived near Delacroix, went to ask his advice, complaining especially of the impasse to which the teaching of Romantic painting had led him. "What do you expect them to teach you?" Delacroix is said to have replied. "They know nothing." Even Delacroix could hardly help Moreau here. He was not a gifted teacher and could barely tolerate the presence of pupils; he had even closed down, after a few months, a workshop he had opened around 1848. Although it is unlikely that Moreau was actually taught by Delacroix, the elder painter nevertheless closely followed his progress and on the evening of Chassériau's burial wrote in his journal: "Poor Chassériau's funeral. Dauzats was there, also Diaz and the young painter Moreau. I rather like him."

For five or six years Moreau's painting was influenced by the work of Delacroix, one of whose greatest history paintings, *The Judgment of Trajan,* he copied in the Rouen museum. Between 1850 and 1855 he made a series of small paintings which, in their spirited style and composition, recall those of Delacroix. At first he took subjects from Shakespeare, whose work Delacroix had already illustrated: Hamlet, King Lear, Lady Macbeth, and others. And following the great Romantic's example he even tried making etchings and provided his friend Berchère with drawings on Shakespearean themes to transfer onto copper plates. Delacroix had painted scenes of violence and rape, and Moreau followed his example in some fairly large paintings such as *Venetian Girls Carried Off by Cypriot Pirates* (Town Hall, Vichy), *The Song of Songs* (Dijon Museum), or the *Scottish Horseman* (Gustave Moreau Museum, Paris), influenced by the *Tam O'Shanter* that Delacroix had painted after a ballad by the Scottish poet Robert Burns. One of Moreau's first biographers, Paul Flat, was among the few to emphasize the influence of Delacroix at a time when, following Huysmans, critics insisted that Moreau had not been influenced by anyone:

> Moreau succumbed to, absorbed, and actively wanted this influence, not only in his working methods, but also in the original ideas and conceptions for his paintings. In *The Legend of King Canute* [Gustave Moreau Museum, Paris], for example, the Romanticism is purely in the manner of Delacroix, from the composition as a whole to the gesture of the king as he turns to his courtiers, the red of his drapery, and the dramatic color of the sea and sky, reminiscent of *Dante's Boat;* and, as can happen with this sort of slavish

Watercolor. 1872. 18.4 × 12.4 cm. Signed bottom left: *Gustave Moreau.* Victoria and Albert Museum, London

For Moreau, Sappho was a positive heroine, ranked with the great poets Hesiod and Orpheus as one of the founders of civilization. He wrote: "I want my Sappho to have the sacred character of a priestess, but a poetic one. I wish her costume to evoke ideas of grace, severity and, above all, imagination —that most important quality in a poet. I have scattered her robe with flowers, birds and all manner of creations that are reflected in the poet's mind."

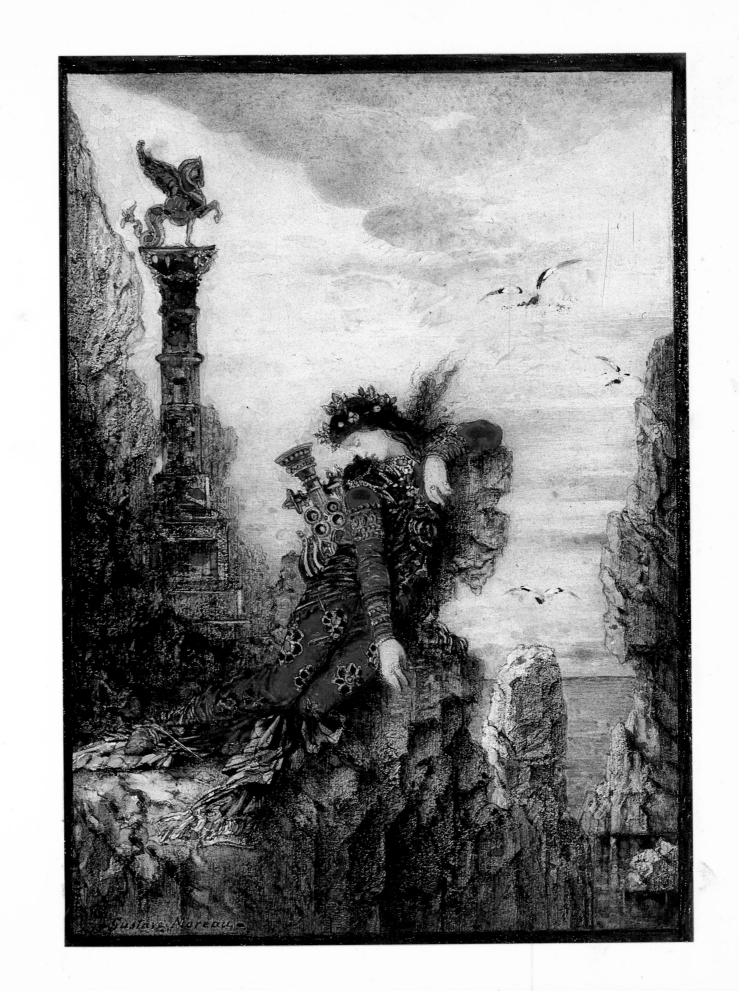

influence, even the master's defects can be detected in his work. The hands are only roughly sketched, hardly there at all, just as Delacroix often used to paint them.

To the influence of Delacroix, then already old and out of touch, was added that of Théodore Chassériau. He was only seven years older than Moreau, but in 1850 he was already an established painter with plenty of commissions. Ill luck dogged this artist, who died at the age of thirty-seven and whose most important work, the decoration of the Cour des Comptes in Paris, was almost completely destroyed by fire during the Commune.

A precocious draftsman, the young Chassériau entered Ingres's studio at the age of twelve, won his first medal at the Salon at seventeen, and broke away from Ingres's teaching at twenty. He turned instead to Delacroix, embracing Romanticism with such enthusiasm that Baudelaire accused him of plunder. It was with Chassériau that Moreau associated himself at the end of 1850, becoming a keen member of his studio. Here he met Puvis de Chavannes, to whom he remained close for the rest of his life. Puvis followed in Chassériau's footsteps in the decoration of public buildings—for which Moreau rather envied him—and it is traditional to regard him, along with Moreau and Redon (to whom we shall come later) as one of the finest exponents of Symbolist painting in France, although in fact he worked more on allegorical painting. It is difficult to assess how much Moreau owed to Chassériau, given that the latter was also indebted to Delacroix. By trying to follow in Chassériau's decorative vein, Moreau reached an impasse and, as has already been mentioned, he never finished any of the large canvases he began in his youth. However, his conception of the female form derives from Chassériau, even if Moreau's women are never as shapely as those painted by his sensual mentor. In both these painters' work, women are seen as beautiful, dreamlike creatures, rather passive and distant, made to be adorned with jewels and dressed with sumptuous fabrics. For Chassériau, however, women were creatures of flesh and blood, who had made love and known pleasure, while for Moreau their beauty was untouchable and pristine, cool and pale as marble, perpetuating, as Mallarmé would have said, "the horror of being a virgin."

Chassériau's sudden death in 1856 moved Moreau to dedicate a painting to his memory. He worked on *The Young Man and Death* (Fogg Art Museum, Harvard University) for nearly ten years before showing it at the Salon of 1865, and he made several versions in watercolor. In the painting allegory is mixed with symbolism. Chassériau is shown, idealized, as a young man in his twenties, entering a palace of marble. The bird flying across the picture (this bird, either red or blue, is found in many of Moreau's works, causing Proust to regard it as a kind of signature) and the bush on the right remind us that he has just left the world of the living and of earthly glory, the latter symbolized by the crown of laurel he holds above his head. Death is present in the guise of a young girl

Watercolor with gouache highlights. Between 1880 and 1885. 37 × 24.5 cm (corners cut). Bottom left in pale green: *à mon ami Charles Ephrussi / Gustave Moreau;* bottom right in pale green: *Galatée.* Private Collection

As if encased in a fabulous marine world, the nymph Galatea, white as milk (as the very etymology of her name implies), is depicted dreaming in the depths of her grotto, as the Cyclops looks on forlornly. She is the pure, angelic, and untouchable woman, the very antithesis of the *femme fatale*—a theme that obsessed many painters, writers, and musicians during the second half of the nineteenth century. Charles Ephrussi, the influential art critic who was in charge of the *Gazette des Beaux-Arts,* owned several of Moreau's works. He also collected paintings by Renoir, who accused Moreau (whom he did not consider talented) of putting gold in his paintings in order to attract potential Jewish purchasers.

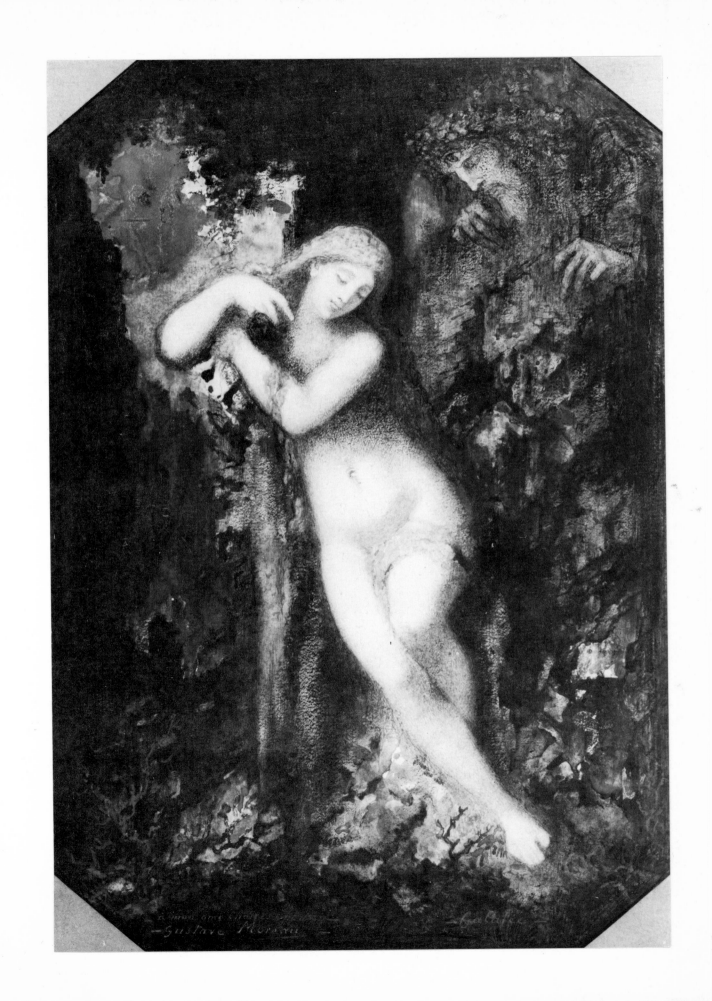

sleeping (his first idea had been to show Death as an old man or a skeleton), with a pure face, who seems to envelop the young man with her floating body. Her slender form contrasts strongly with the manly bearing of her young companion. The hourglass and the long sword she is holding, the putto trying to upset the torch, the bunch of jonquils (the flowers of Persephone), the lilies and wreaths of poppies that crown the head of Fate, are all discreet but ominous reminders of death.

The Young Man and Death is both an homage to and a departure from Romanticism. Between 1856 and 1865 Moreau gradually managed to achieve an individual style. During the same period he came into his own. He was nearly forty when he found success at the Salon with his earliest Symbolist works: *Oedipus and the Sphinx*, (Metropolitan Museum, New York) in 1864, *Jason* and *Orpheus* (Louvre, Paris) in 1865. From Delacroix and Chassériau he retained a richness of coloring, carmine reds, deep greens, peacock blue, ochers, and violet, and all the power with which color can be worked and manipulated to express feeling. Like Delacroix, he believed painting to be an inherently rich art form with its coloring and impasto, which Moreau used ever more thickly, making it sparkle, set into the canvas like jewels and precious stones. He communicated this love of color to his pupils, the Fauves, thus forming a link between Romanticism and Fauvism. "Be sure of one thing," he told them. "You must consider colors with imagination. If you do not use your imagination you will never achieve beautiful coloring. You must use nature with imagination: that is what makes an artist. Color must be thought out, dreamed of and imagined."

He became interested in enamels, fascinated by the brilliance of their coloring, and he used to visit the Bibliothèque Nationale to study the Persian and Moghul miniatures and medieval illuminated manuscripts, attempting to discover the secrets of coloring from the artists of the past. Indeed he once exclaimed to his young pupil Rouault, in front of Rembrandt's *Bathsheba,* admiring the artist's achievement of effects with dull, earthen colors, "There are times when I would give everything for Rembrandt's mud." He even experimented with color in order to convince himself that the organization of color in a painting was due to an inner order peculiar to the artist himself. This could not be provided by a studio training or the laws of physics as was propounded by the neo-Impressionists, with whom he disagreed strongly. "I tried to imagine putting crimson and other rich coloring in a work by Rembrandt," he wrote, "and I became sure that it was impossible to introduce any bright coloring or tone into his somber harmony without utterly destroying the depth and intimacy of the thoughts involved."

To his coloring Moreau added a decorative profusion that caused Degas (who knew Moreau well and in his youth was even influenced by him) to remark, "He hangs watch chains on the gods of Olympus." His *horror vacui* caused him to clothe his figures in brocades, richly embroidered belts, and stoles, with tiaras and diadems in their hair, to cover their arms, ankles, and necks with masses of

17
LEDA AND THE SWAN

Watercolor highlighted with gouache. Between 1875 and 1880. 34 × 21 cm. Gustave Moreau Museum, Paris

Moreau very rarely portrayed women in reclining positions; more frequently they are shown standing or half seated, a fact that would probably interest a psychoanalyst. For Moreau the myth of Leda was not an excuse to paint a lascivious scene, as it is with most painters, but takes on a sacred meaning, akin to the Christian mystery of the Annunciation. Consequently this scene, where Leda, leaning against a tree trunk, seems to have taken great pleasure in her encounter with the swan, is exceptional in the artist's work. The deftness of execution is particularly striking in this composition based on diagonals, as is the richness of color, achieved by the use of gouache.

40

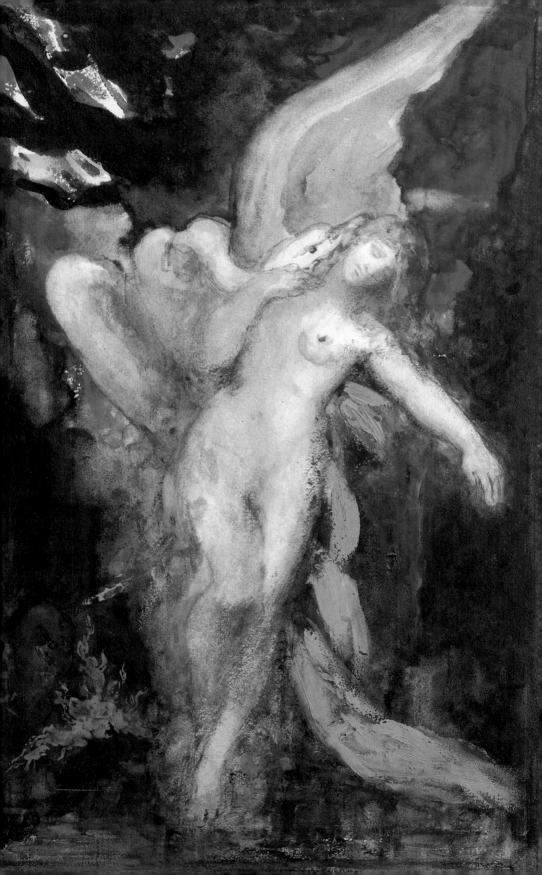

bracelets and gems to the extent that he could be charged with having raided the world's treasure-houses of crown jewels. Delacroix, in *The Death of Sardanapalus*, and Chassériau, in *Susannah Bathing,* had already shown their propensity to endow their paintings with a jewellike surface, but Moreau pursued this Romantic trait to an almost obsessive degree, going so far as to tattoo designs on the very bodies of his figures, as in *Salome Dancing* (Gustave Moreau Museum, Paris), where her chest and stomach are decorated with a stylized lotus flower, while at her navel two monstrous heads taken from Etruscan jewelry confront each other. Of works such as *Salome* or *Jupiter and Semele* one can use the term fantastic in its truest sense. Roger Caillois remarked that Salome, the Hebrew dancer, was suddenly transformed into "some aboriginal savage, somehow transported from a distant continent and entangled in the wild, fateful religious events of the scriptures. This fantasy is not so much a mixture of time and place as a merging of differing cultures and moralities." The almost deliriously descriptive nature of such paintings has a parallel only in contemporary literature, especially in Flaubert's *Salammbô* and Mallarmé's *Herodiad.*

This passion for precious stones, for sumptuous and varied effects, and the penchant for heavy, even flashy decoration, makes Moreau a true representative of the ostentatious taste of the Second Empire for riches and luxury. After all, Moreau was an exact contemporary of Charles Garnier, the architect of the Paris Opéra, and any modern counterpart of Taine would hardly pass over the opportunity of emphasizing the influence of the artistic *milieu* on his painting. In justification of this principle of "the necessity for splendor" Moreau pointed to the Old Masters, in front of whose works he advised the young Rouault, Matisse, and Marquet to place their easels:

> Look at the Old Masters. They all tell us not to impoverish art. In all periods they used the richest language they could in their paintings, the rarest, most brilliant and even the oddest elements around them which they considered worthy or precious. For them a subject became more noble when steeped in a profusion of decorative elements.... Look at their Madonnas, incarnations of the highest beauty; yet see how they have been treated, see the jewels, the rich robes, and their carved thrones! And how these saintly figures come to life! Could you say that the heavy jewelry with which Rembrandt weighs down his priests makes them more realistic? Or that the regal splendor of Van Eyck's Virgins prevents them from being pious or contemplative? On the contrary, the rich effects and accessories of the Old Masters, which constitute such an amazing range of quality, strengthen the abstract nature of their work, and even in the great primitive paintings they include, for example, a beautiful but irrelevant beast, bunches of flowers, festoons of exotic fruits, or a lovely, gracious animal. Whether they came from Flanders or Umbria, Venice or Cologne, painters strove to

18
A WOMAN AND A DRAGONFLY

Watercolor highlighted with white gouache on cream paper. C. 1884. 22.5 × 33.5 cm. Signed bottom right: *Gustave Moreau.* Gustave Moreau Museum, Paris

This small, rapidly and fluently executed sketch corresponds to one of the motifs in the painting of *The Chimeras* (Gustave Moreau Museum, Paris): "A devilish Decameron," Moreau explained to his mother, "where all the nuances of the dark side of women's dreams are found." He added: "To give you an example, the figure being carried off by a water-bred insect, often known as a damsel fly, represents those ethereal creatures, of delicate sensibility, who continually dream of being carried away by a gentle breeze."

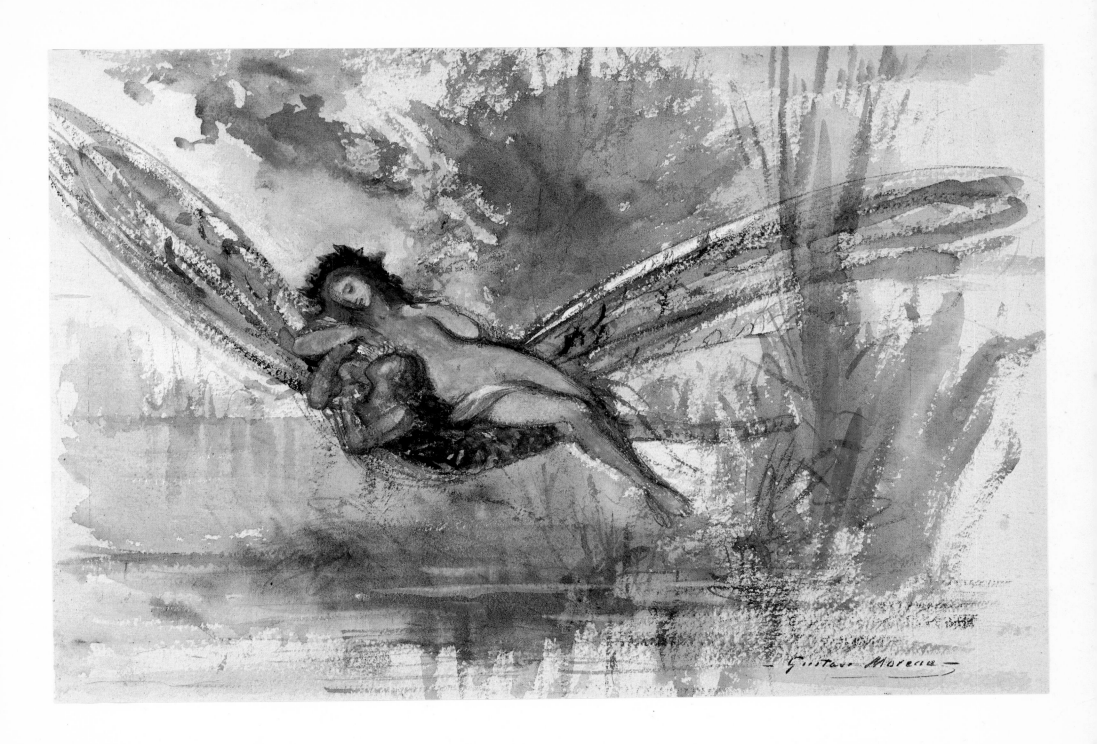

Gustave Moreau

invent the own, slightly unreal world. They even created imaginary skies, clouds, places, and architecture, often with strange and wonderful effects. Think of the towns Carpaccio or Memling would build for Saint Ursula, or the Tarsus that Claude Lorrain built for his Cleopatra! Or the valleys that c to the azure skies of the Lombard painters! Museums everywhere have ws opening onto artificial worlds formed out of marble and gold, aces that are unreal.

One can see n these words why Moreau's pupils would have been entranced by his t hing, even if the examples he chose were more a statement of his feelings than a lesson in the history of art.

The Master of Symbolism

Moreau would have been surprised to learn that he was regarded as a Symbolist painter, although, when commenting on his own work, he often used—if rather vaguely—words like "ideal," "symbol," "symbolize," "allegory," and "emblem." He was deeply knowledgeable about religious and mythological iconography. When composing his paintings, he used dictionaries of mythology, notably Noël's *Dictionnaire de la fable* of 1801, one of the earliest dictionaries of comparative mythology, and Jacobi's *Dictionnaire mythologique universel* of 1863. He liked to combine tales from the Bible with those of Ovid and Hesiod, and Goethe's Faust with Homer's Helen. In this respect it is Flaubert, in his *Temptation of Saint Anthony,* who is most like Moreau.

Critics and art historians often find it necessary to classify painters and define various schools. It is well known that the term Impressionist was first used by journalists as a term of derision, and yet it continues to be used to cover a group of painters as diverse as Monet and Degas. Altogether broader, the word Symbolism covers both a literary movement and one in painting, just as the term Romanticism did at an earlier date. Before becoming a Symbolist, Moreau, as we have noted, thought of himself as a history painter, as Ingres and Delacroix considered themselves history painters rather than Neoclassicists or Romanticists.

At a time when Moreau was beginning to make a name for himself, toward the end of the Second Empire, there were several mainstreams in French painting. Some artists strove to continue the grand academic tradition of history painting, manifested in historical reconstructions (Gérôme); others sought photographic precision and anecdotal painting (Meissonier); others portrayed the female nude on a mythological pretext (Cabanel); and for others there was the realism of Courbet and Millet. Landscape, unless historically significant, was still considered a minor genre. Manet scandalized established taste by deliberately

Watercolor. 1885. 31.5 × 17.7 cm. Signed bottom left in yellow: *Gustave Moreau;* bottom right in yellow: *LE SPHINX.* Clemens Sels Museum, Neuss, West Germany

Although this watercolor was painted in 1885, a closely related drawing is dated 1860, when Moreau was working on *Oedipus and the Sphinx* (Metropolitan Museum of Art, New York), a work he showed at the Salon of 1864. Here there can be no doubt that the Sphinx is viewed as the female devourer of men. This is an image of the fatal heroine, unwavering in her gaze, whose prey is a constant stream of men, now reduced to broken toys, scattered at her feet. During Moreau's time misogyny was widespread. It can be found in the work of writers such as Vigny, Baudelaire, and Huysmans, whom Moreau especially liked, and Schopenhauer and Wagner, whose works he also possessed.

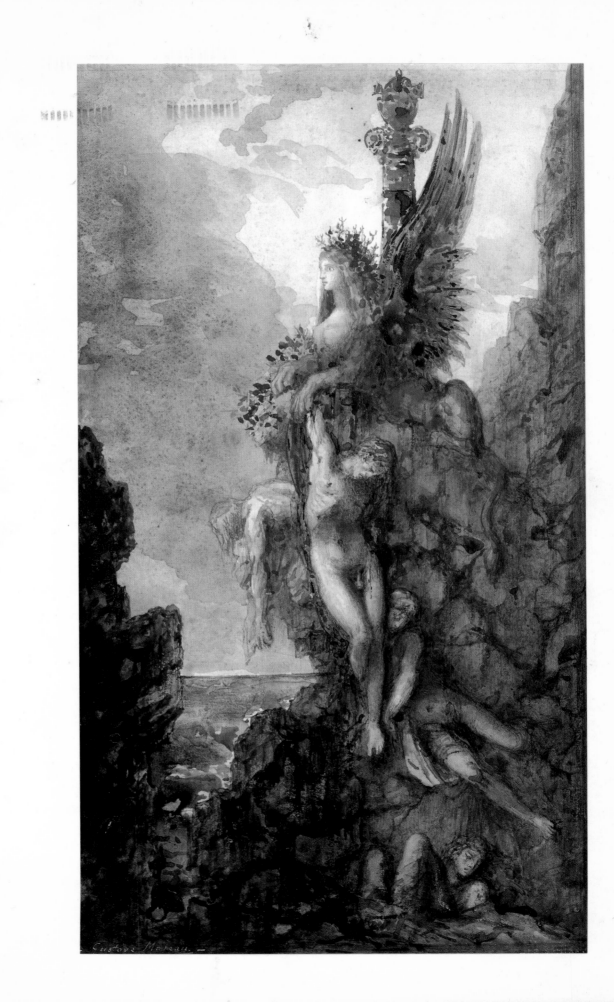

Gustave Moreau.

choosing modern subjects. By limiting himself to painting mythology for its own sake, Moreau directed the attention of the public to the hidden meanings of classical legends. His first success, for example, *Oedipus and the Sphinx,* aimed to represent the battle between the sexes rather than to tell the story of the monster who asked riddles of those who passed by. Redon, who was twenty-four in 1864, describes very well the spirit in which this painting was received: "It was pure naturalism, and how that work affected me! I have long remembered that first impression, and it was this that gave me the will to follow a single course, alongside his own, perhaps, mainly because of its power of suggestion, so dear to writers."

Before 1870 the term idealism was used to describe Moreau's work, which appealed, as Théophile Gautier put it, "to the refined, the fastidious, and to the curious who have always been familiar with the Old Masters and who are so bored with the art of today that they are driven toward the primitives, whose childlike freshness rouses them from indifference." Several years later these connoisseurs became known as Decadents or Symbolists.

It is not unusual for an artistic movement to acquire its name from an antagonist. In Moreau's case the great master of Naturalism, Emile Zola, was the first to use the word Symbolist when the artist, after a self-imposed exile from the annual Salon, made a comeback in 1876, with *Salome Dancing* (Los Angeles County Museum) and *Hercules and the Lernaean Hydra* (Art Institute of Chicago). Moreau's work irritated him, and he saw in it

> the most extraordinary extravagances an artist can perpetrate in his quest for originality, as well as a hatred of realism. Naturalism today and the efforts made to study nature must, of course, provoke a reaction and produce imaginative painters. But this step back into the realms of imagination has taken a particularly interesting turn in the work of Gustave Moreau. He has not retreated to Romanticism as one might expect.... No, Gustave Moreau has moved into Symbolism. His talent consists of taking subjects that have already been illustrated by other artists and reworking them in a new, more ingenious way. He paints his dreams—not the simple, childish dreams that we all have, but sophisticated, complicated, enigmatic dreams in which, at first, it is difficult to find our bearings. What value can art like this have these days? A question for which there is no easy answer. As I have said, I see it as a straightforward reaction to the modern world. There is no room for science here. We simply have to shrug our shoulders and move on.

At the same exhibition, however, one of Zola's disciples, Huysmans, was fascinated by Moreau, and even Zola was still intrigued by him. In fact, his reaction to Moreau's work was a mixture of repulsion and uneasy attraction, to the extent that in *L'Oeuvre,* the novel in the Rougon-Macquart series devoted to art, the hero, Claude Lantier (in whom many contemporaries believed they

20
<small>MESSALINA</small>

Watercolor. 1874. 58 × 33 cm. Gustave Moreau Museum, Paris

The life of debauchery of the emperor Claudius's wife both fascinated and repelled Moreau, who sought to express here "one of the most terrible passions of men and women: the love of the senses." He went on: "The idea here is of a debauching woman heading for death. The daughter of the Caesars, one foot on a stool, the other leg folded back along the edge of her coarse and soiled bed, entices a young boatman from the Tiber.... This overtly sensuous scene is witnessed by an old crone, motionless and holding a torch.... Through the window under a starry sky is a view of the magnificent Rome of the Caesars, with the famous monuments to its heroes."

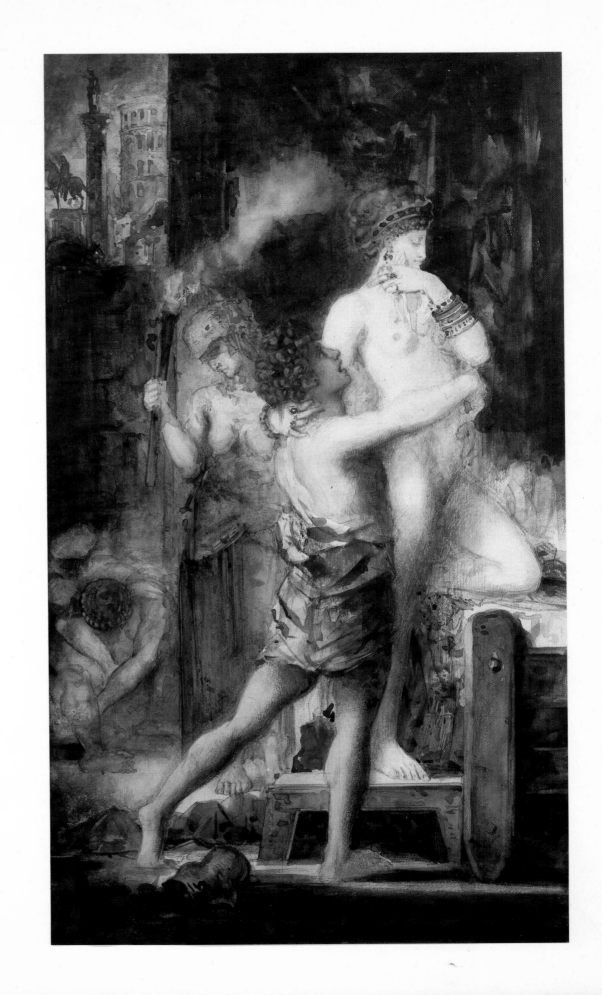

detected traces of Manet and Cézanne), before hanging himself, painted a colossal female nude which, like Moreau's *Salome,* had

thighs that formed the columns of a temple, her stomach an ethereal star, sparkling bright red and yellow. Her nudity is like a monstrance where the jewels seem to call for some act of worship.... Who could have painted this goddess of an unknown religion? Who could have composed it of precious gems, metals, and marbles into the mystic rose of her sex, between the exquisite shafts of her thighs, beneath the sacred vault of her belly? Could it really have been he who, unwittingly, had become the creator of this symbol of eternal desire, this superhuman image of flesh which has become gold and diamonds in his hands, and was it for him a means of escape from life?

It was only in 1890 that an art critic, Georges-Albert Aurier, attempted to explain the tenets of Symbolism in painting. He used Paul Gauguin as an example, while emphasizing the importance of Gustave Moreau, Puvis de Chavannes, and the English Pre-Raphaelites. The parallel between Gauguin and Moreau is worth examining further, so different are their two styles. Like Moreau, the nomadic Gauguin had a keen sense of the spiritual, and pronounced: "Before nature herself it is our own imagination that creates the painting." To escape the civilization and people of his own time, Moreau took refuge in the solitude of his studio. Gauguin set off for the South Seas, where he hoped to find inspiration and rediscover the ancient gods and the primitive purity of man as yet untouched by technological progress. His pictorial testament to this, *Where are we from? What are we doing? Where are we going?,* has its equivalent in Moreau's work *The Life of Mankind.* This is a polyptych of the medieval type, where the legend of Orpheus alternates with the Bible in symbolizing the Three Ages of Man. Unlike Gauguin, Moreau believed he would find the innocence of an earlier age in the Greek myths and the Italian primitives. These are two very different approaches to a similar ideal: to express in form and color what is beyond the natural world.

It is the names of Puvis de Chavannes and Redon, however, that are usually linked with that of Moreau as the founders of the Symbolist movement in France. Historically the three men are united by a true similarity of ideas and by a personal friendship that made them a genuine group. It has already been noted that the art of Puvis de Chavannes—like that of Moreau—derived from Chassériau, whose studio they used to frequent at the same time. It seems unfair that Puvis de Chavannes is still deprived of the prestige that our own times lavish on Moreau and Redon; he is still considered to be an official and academic painter, which he never was. Perhaps this is because he spent too much time decorating municipal buildings and was chained to subjects concerning local history and dictated by petty officials. Redon, of his own admission, could never

21
DELILAH (detail)

Watercolor over pencil drawing. 1882. 15.8 × 21.3 cm. Signed bottom right in gold: *Gustave Moreau;* bottom left in gold: *DELILAH.* Cabinet des Dessins (Hayem Bequest), Musée du Louvre, Paris

Rapt with love, Samson has fallen asleep in a less than masculine pose on the lap of Delilah, who has just picked up her scissors. Especially striking is the tangled design formed by the two bodies. André Breton was particularly fascinated by Moreau's *Delilah,* and in *Les Vases communicants* he wrote of an unexpected meeting with an unknown woman "who had such eyes, such wonderful eyes, that they have held me entranced for fifteen years: she is the Delilah by Gustave Moreau whom I have seen so often in the Musée du Luxembourg."

48

conceal his debt to Moreau, whom he often visited in the rue Rochefoucauld. On many occasions Moreau's works provided a basis for his own, as if they were for him seminal images, altered and translated into the world of an even more individual spirit.

All three artists mixed with writers and poets, and Redon liked to illustrate their literary works. The situation was reversed in the case of Moreau (although he did illustrate the *Fables* of La Fontaine). His paintings inspired writers, especially the poets of the Symbolist generation between 1880 and 1900. Although he was older, he anticipated their tastes and their deepest aspirations. He eschewed the promiscuity of the common people and their democratic spirit; he was fond of the dusk and sunsets, the colors of autumn, the gentle waters of a spring, jewelry and decoration; he venerated love, death, and the untouchable, regal beauty of princesses; and he was obsessed by ancient myths and the picturesque crimes found in the Bible. All the young "snobs"—the word appeared in France around 1890—became admirers of Moreau. Among them was Marcel Proust, who devoted several essays to him between 1895 and 1900 and who, when creating the character of the painter Elstir in *Remembrance of Things Past,* imagined that the artist, before he became an Impressionist, had made watercolors of mythological subjects. The finest of these, *Poet Meeting the Muse* and *Young Man and a Centaur* (titles that could be describing works by Moreau) adorned the chamber of the Duchesse de Guermantes. These watercolors "were not his best work," as the narrator says, "and people who regarded themselves as being enlightened were prepared to go so far but no further." Although later in his career Elstir became a painter of fleeting moments, during his Symbolist period he was able "to imbue the symbolism of a story with real historical truth."

Asked who his favorite painters were, Claude Debussy replied "Botticelli and Gustave Moreau." And when Victor Segalen proposed writing the libretto for an opera, Debussy suggested a setting of Orpheus inspired by Moreau's work. (He died before being able to start the project.) Segalen would really have preferred to write a text in which he could use his knowledge of Buddhism; however, in 1907 he went to the Gustave Moreau Museum to familiarize himself with the painting, and shortly afterward he wrote a study entitled *Gustave Moreau, Images of Orpheus,* in which he treated Moreau's painting harshly, preferring Monticelli and Gauguin, through whom he had rediscovered aspects of the South Seas.

At the beginning of the twentieth century, Moreau's reputation began to decline rapidly, and with the number of visitors growing fewer and fewer, the Gustave Moreau Museum, which had opened in 1903, gave the impression of a sad, dusty mausoleum rather than a monument to the artist's greatness. The elderly Degas, who also considered leaving the contents of his studio to the state, decided against this after spending a few moments in the rooms of the museum. "It is terribly sinister," he said as he left. "One could imagine oneself being in

22
HELEN UNDER THE WALLS OF TROY (detail)

Watercolor highlighted with gouache. C. 1885. 40 × 23 cm. Signed bottom right: *Gustave Moreau.* Cabinet des Dessins, Musée du Louvre, Paris

Like Salome, Delilah, and Messalina, Helen is a heroine who is cursed, not through her wickedness, but through her beauty, which unleashed the Trojan War. Huysmans described the painting, of which this delicate watercolor is a reduced version: "Dressed in a robe studded with precious stones like a reliquary, holding a flower in her hand like the Queen of Spades, walking slowly, lost, eyes staring ... she dominantes the battle, majestic, serene, like Salammbô appearing to the mercenaries as an evil goddess."

a catacomb.... All those canvases gathered together have an effect similar to reading a thesaurus or a Latin dictionary."

Moreau's work, like that of the Symbolists, was soon overtaken by the new generation, which saw an extraordinary number of changes, including Fauvism, Cubism, and abstraction. Moreau's sole merit seemed to have been that, due to the liberal nature of his teaching, he had nurtured the talents of Matisse, Rouault, and Marquet. Only the young André Breton, around 1910, discovered female beauty in Moreau's work, and he was entranced. But, although he immediately recognized Moreau as a precursor of Surrealism, his lone admiration was not enough to keep the artist's work from obscurity. It was not until 1961, with an exhibition organized at the Louvre on the initiative of André Malraux, that the work of Gustave Moreau attracted attention once more, nearly a century after his first success at the Salon of 1864. Many artists and writers have remained in limbo for longer.

23
Pietà

Watercolor highlighted with white gouache. C. 1882. 20 × 26.5 cm. Signed bottom left: *Gustave Moreau*. Cabinet des Dessins (Hayem Bequest), Musée du Louvre, Paris

Though not a churchgoer, Moreau was a deeply religious man. A large part of his work illustrates scenes from the Old Testament, the Gospels, and the lives of the saints. While he gave rein to his imagination in mythological or quasi-religious works, such as *Salome* and *Saint Sebastian*, he remained close to the scriptures when handling strictly religious subjects. This reverence for the Gospels restricted him from getting away from traditional iconography, yet it must be admitted that he painted these scenes with emotion and piety.

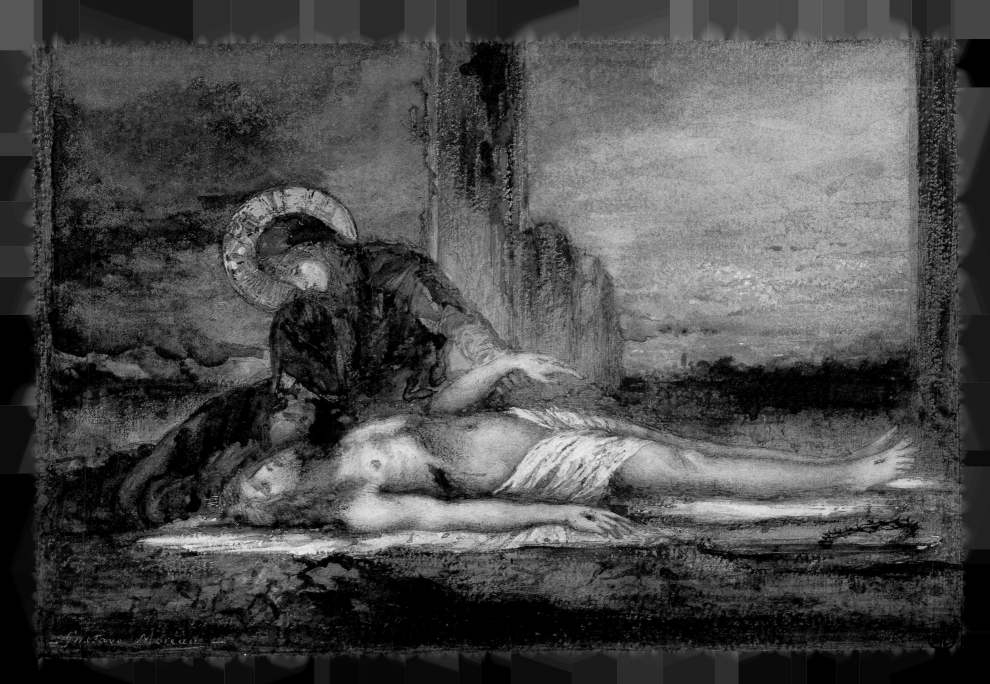

Gustave Moreau

HERCULES AND THE LERNAEAN HYDRA

Watercolor highlighted with gouache. Between 1876 and 1880. 26 × 51 cm. Signed bottom right: *Gustave Moreau*. Gustave Moreau Museum, Paris

This watercolor, a pendant to the *Pasiphaë,* hung in the living room of Moreau's mistress. It shows the confrontation between Hercules and the Hydra, a monster with many heads, each of which Moreau copied from beasts in the zoo of the Jardin des Plantes. Almost all the labors of the demigod Hercules were illustrated by Moreau, and this watercolor is a variation of the painting he presented at the Salon of 1876 (Art Institute of Chicago). For Moreau, Hercules was not the coarse, muscle-bound superman one often finds, but an Apollolike hero, whose labors are triumphs over evil and passion. The artist has chosen the moment when the two antagonists are appraising each other, rather than their actual fight. He often preferred to depict the scene before or after an event and not the event itself.

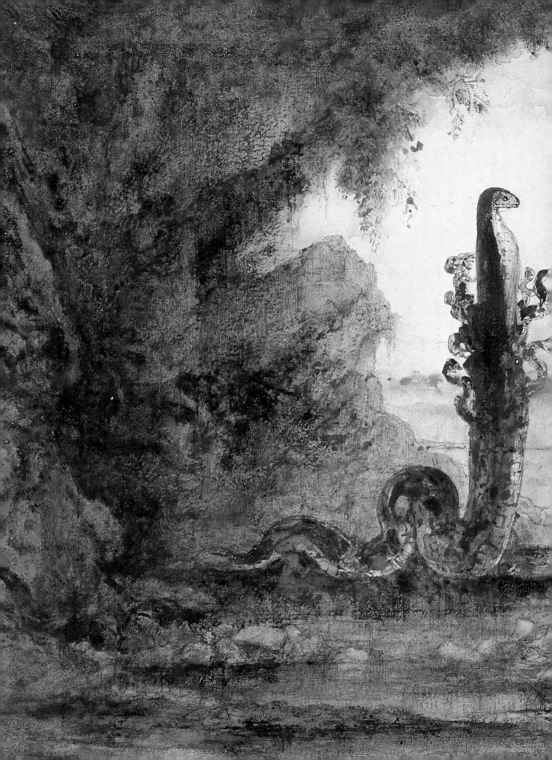

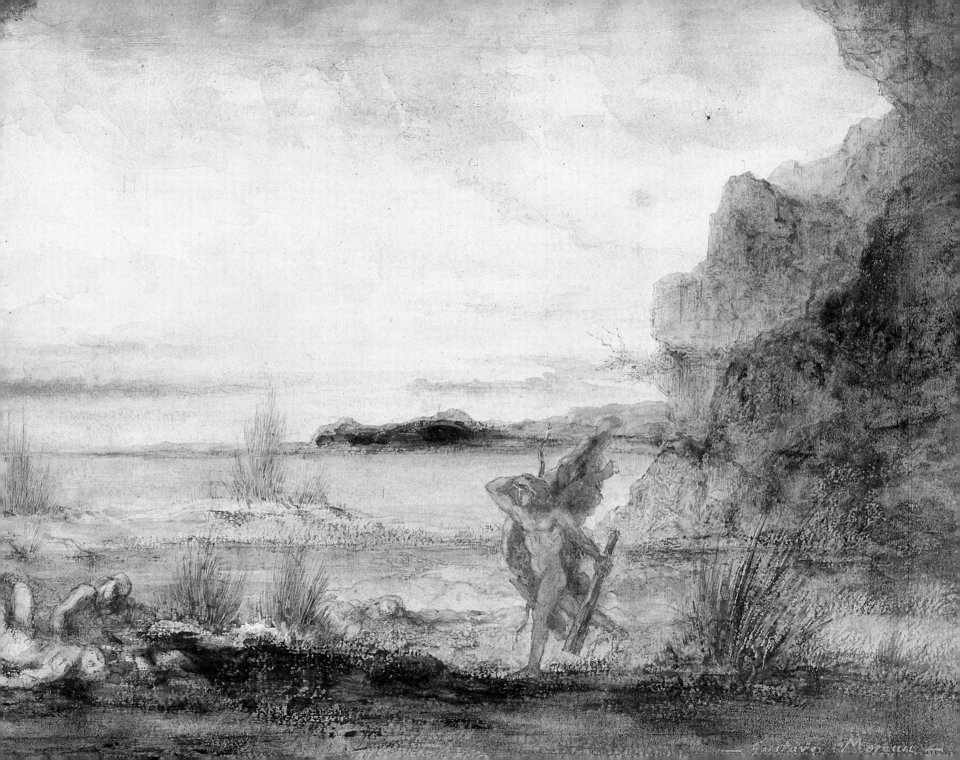

25
PASIPHAË AND THE BULL

Watercolor highlighted with gouache. Between 1876 and 1880. 26 × 51 cm. Signed bottom right: *Gustave Moreau*. Gustave Moreau Museum, Paris

This painting illustrates the story of Pasiphaë and her monstrous union with the bull. A victim of Poseidon's revenge, King Minos's wife was caused to fall in love with the animal. In order to fulfill her passion she commanded the inventor Daedalus to make a hollow cow of bronze in which she could position herself. The fruit of this encounter was the Cretan Minotaur, which Moreau showed in one of his earliest paintings. He placed the scene in a woody glade at sunset. This watercolor, highlighted with red gouache, is dominated by tones of green and red. One wonders why the painter gave his mistress a work of this nature.

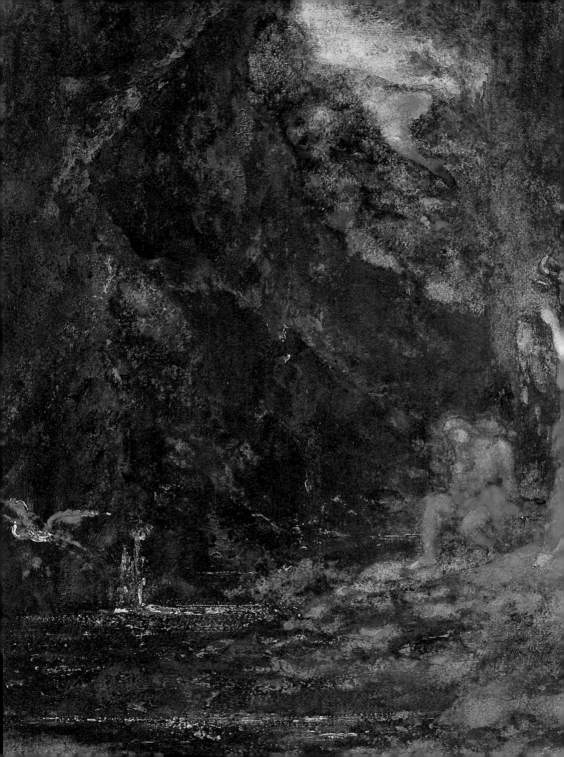

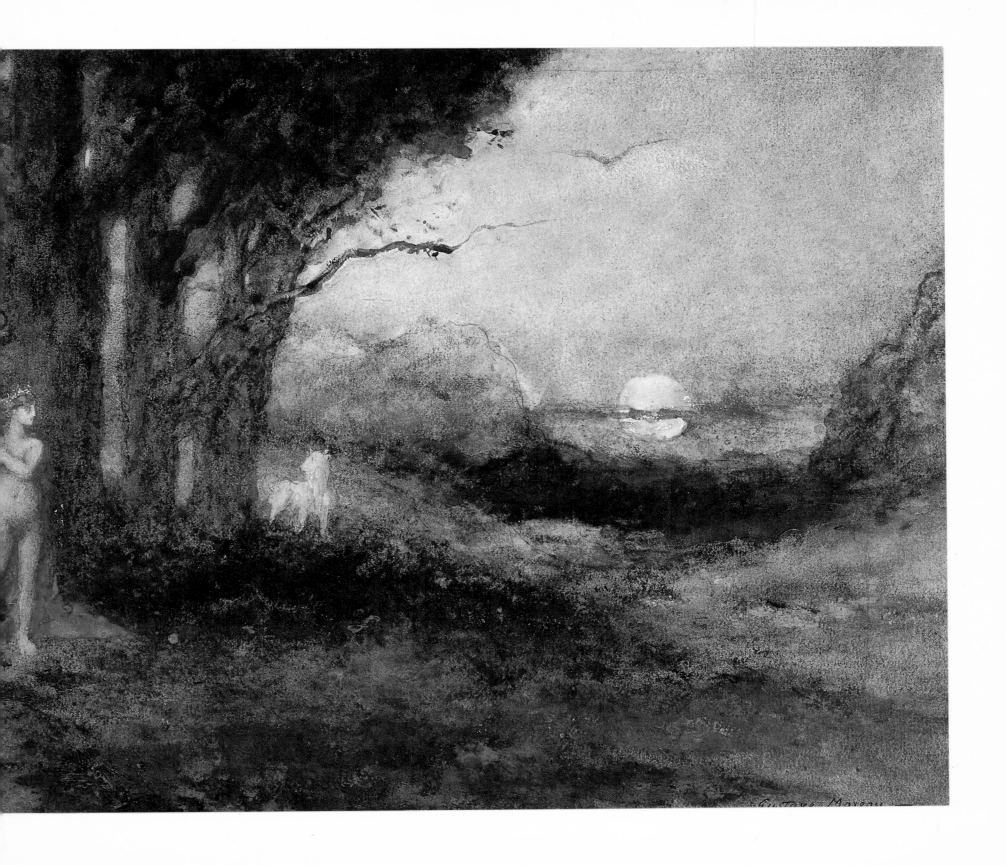

Chapter II The Master of Watercolor

Touches of Color

Watercolor is a technique that is little appreciated and little known, perhaps because it falls between drawing and oil painting. Even one as discerning as the philosopher Alain, in his *Twenty Lectures on the Fine Arts,* considered it a "bastard genre" and remarked of watercolor and pastel that "even at their most refined they do not approach the expressive possibilities of oil painting. And it is generally agreed that watercolor cannot rival drawing, perhaps because of its thin and insubstantial nature. In watercolor, as in drawing, what counts is the paper."

To a great extent watercolor is essentially a vehicle for study. People taking up painting generally begin with watercolor. And not so long ago it was considered—like the piano—a suitable and fashionable pastime for young ladies of breeding. In addition, watercolors are remarkably vulnerable, especially to sunlight, and they are safest when hidden away in the collector's portfolio or in the archives of a museum, and rarely seen. Each time they are exposed to light they lose something of their perfection, and even the best restorers dare not touch them since the slightest damage to them is irreversible. Moreau's watercolors are no exception, and although he frequently highlighted them with gouache, a thicker and less fragile medium, some of them can no longer be seen. For a long time painters, especially in France, used a monochrome wash—of bister and then sepia—rather than a full range of watercolor. Indeed the French term for watercolor, *aquarelle,* which comes from the Italian, did not exist until the end of the eighteenth century. For David and his pupils watercolor was a medium of little interest, serving mainly for scenery and costume designs for the use of stage designers and dressmakers.

It was in England, in the mid-eighteenth century, that watercolor achieved a new status, when landscape painters used it almost exclusively. This came about by default: traveling through Europe to Italy these artists, often on foot, could not be encumbered with canvas and oils, but a box of watercolors and a sketchbook were no burden. Amateurs and professionals alike returned from their journeys with topographical views, seascapes, and picturesque scenes

26
GIRLS AND FLOWERS

Fan-shaped watercolor. 1882. Diameter 49 cm; width at either end 11.5 cm; width at center 15 cm. Signed bottom right: *Gustave Moreau 1882.* Gustave Moreau Museum, Paris

This fan-shaped watercolor was made for Alexandrine Dureux. The subject is similar to that of *The Chimeras,* but is more imaginative and delicate, as befits its essentially decorative function. Moreau makes no allusion to the perverse nature of women here; he simply offers a poetic evocation of winged young girls darting from flower to flower. These tiny creatures, who live in the flowers, plants, and algae, became increasingly frequent in Moreau's work from 1880 onward.

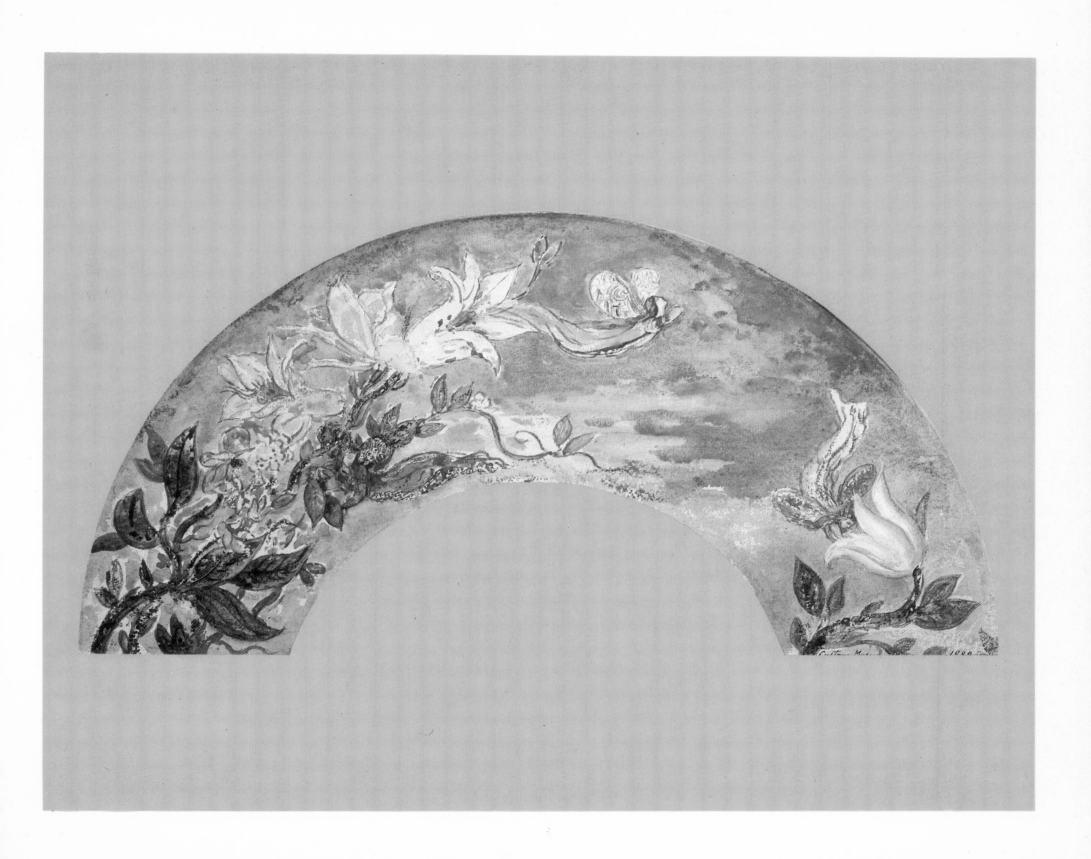

painted from nature. These they sold to their compatriots, who were always eager for exotic scenes and views of Italian towns. Gradually, artists like Paul and Theodore Sandby, Alexander and John Robert Cozens and Thomas Girtin —figures who are little known outside Great Britain today—transformed the art of watercolor painting; their lead was followed by J. M. W. Turner and R. P. Bonington, who became supreme virtuosos during the first half of the nineteenth century.

After the Napoleonic wars, when relations with France had been resumed, British artists such as the Fielding brothers and above all Bonington introduced the "English manner" of watercolor painting into France. It was taken up by almost all the young Romantic painters—including Géricault, Delacroix, Isabey, Lami, and Dauzats—between 1820 and 1830. But this is not the place to trace the history of watercolor painting in France. Suffice it to say that the Romantics, and later the Realists and the Impressionists, were all fervent watercolorists, as could be seen in a recent (1983) exhibition in the Cabinet des Dessins at the Louvre. However, in France watercolor remained a medium for the sketching and study of nature, and it was not until 1879 that an equivalent to the British Society of Watercolorists (founded in 1804) was set up in France on the initiative of Lami. Even then, it was short-lived and was confined to subject painting. Throughout the nineteenth century, watercolors were exhibited in the drawings section of the annual Salon, but these were generally the works of aristocratic amateurs rather than professionals. Nevertheless, Moreau exhibited large watercolors in the Salon of 1876 and in the Paris World's Fair of 1878. Indeed the only one-man show of his work to be staged during his lifetime—which was held at the Goupil Gallery under the directorship of Van Gogh's brother—consisted exclusively of watercolors.

It would be interesting to know what persuaded Moreau to take up watercolor painting. When he returned from his first trip to Italy at the age of fifteen he brought back a few watercolor sketches of monuments he had seen, as was customary for travelers at a time when photography was still in its infancy. We also know that his father did not allow him to take up painting as a career until he had consulted the painter Dedreux-Dorcy, the friend of Géricault and executor of his will. Dedreux-Dorcy collected Géricault's watercolors of horses, and encouraged his nephew Alfred de Dreux to take up watercolor painting in the English manner, which was greatly favored by connoisseurs around 1840. The young Moreau loved horses, and the archives of the Gustave Moreau Museum contain many sketches that he made at the racecourse. A charming watercolor of 1852 showing two horsewomen in top hats, riding sidesaddle on fiery, galloping horses, affords us a scene of Second Empire elegance that is unique in the work of Moreau. Painted in the style of Alfred de Dreux, or even Géricault, the fluidity of the brushwork and masterful use of the paper itself to suggest a sky filled with wispy clouds reveals his total understanding of the possibilities of watercolor.

27
THE SUITORS

Watercolor with gouache highlights. C. 1882. 16 × 25 cm. Gustave Moreau Museum, Paris

Begun in 1852, Moreau's painting of the massacre of Penelope's suitors by Ulysses is a large work which the artist took up on several occasions without ever finishing. This watercolor is similar to the final version of the painting, and displays Moreau's interest in the male body in both conventional and rather ambiguous postures. Most noticeable is the figure of the young prince to the right, derived from a small Roman bronze in the Louvre, which represents the god Attis. He is wearing a baggy Asiatic garment that covers his whole body except his stomach and genitals. Followers of his cult were known to mutilate their genitals during orgiastic feasts.

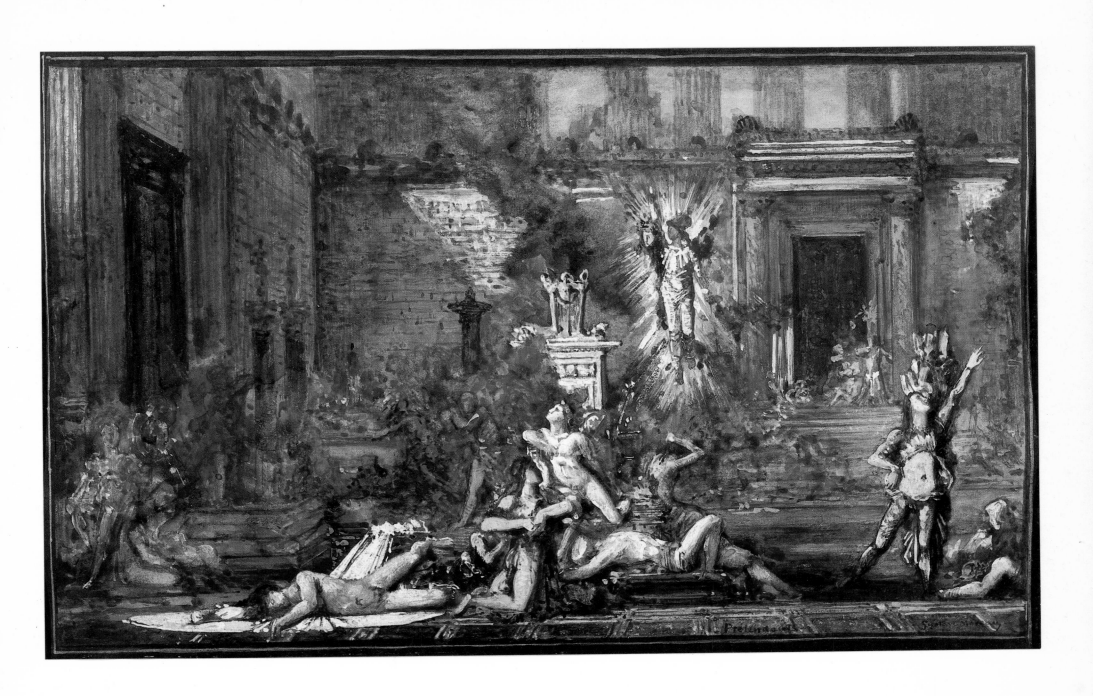

During his stay in Italy in 1857–59, Moreau often used watercolor to copy Renaissance masterpieces. There was a technical reason for this, which he explained to his parents. "The advantage of using watercolor, and the reason I have chosen it over oil, is that in this medium I have been able to capture the matte quality and the lightness of fresco, which I could never have achieved otherwise." His knowledge of the possibilities of watercolor increased through his diligent study of fresco, also a water-based medium. He returned from Rome with watercolors after Sodoma, Michelangelo (a copy two yards long of some of the sibyls and prophets from the Sistine ceiling), and Raphael, experimenting with a combination of techniques in his effort to make accurate copies. For example, in his copy of the famous putto at the Academy of Saint Luke in Rome he used a preparation of watercolor, glue, and plaster, enabling him not only to imitate the original precisely, but also to reproduce its character and technique.

We have already discussed Moreau's travels in Rome and the surrounding Campagna, where he found the landscape "rather monotonous." The few "souvenirs," as he called them, that he made on those journeys make one regret that he did not spend more time painting landscape. But he was absorbed by another, overriding passion: to make as many copies after the Old Masters and the antique as he could in order to master the techniques they had used. During the years he spent in Italy, he painted only one original work: *Hesiod and the Muse,* a seductive painting in brown-ink wash based on an ancient model (the composition derives from a Hellenistic bas-relief). Here he illustrates for the first time the theme of the birth of poetry, harmoniously uniting pure, classical draftsmanship with sfumato effects reminiscent of some of Prud'hon's drawings.

Throughout his career Moreau often used watercolor for preparatory studies for his oil paintings; this is evidenced by the hundreds of sketches in the Moreau Museum, kept in a revolving showcase made specially for them. He would plan his ideas for paintings in small watercolor sketches, in which he would work out the relationships between colors. He also used pastel and red chalk, especially in his early years, finding that their fleshlike tonality was ideal for modeling bodies. Although the present book is concerned with Moreau's watercolors, let us briefly consider one of his red chalk drawings which demonstrates his sensual approach to movement and sculptural beauty. This is one of a series of preparatory drawings for a painting to be entitled *The Unfaithful Handmaidens,* which would have been the female counterpart to his *The Suitors* had he progressed beyond these sketches. Moreau's study of a terrified woman, her arms raised, recalls some of Ingres's sketches in which he was trying to work out the best pose for his odalisques.

The dozens of bold, rapidly executed watercolors in the Moreau Museum display a remarkable unity of color and design; there are no revisions and no reworking, and his ability as a painter can be seen at its most spontaneous, sometimes with happier results than in the finished picture. Take for example

28
SAINT SEBASTIAN

Pencil and black and red chalk. C. 1876. 65 × 36.5 cm. Gustave Moreau Museum, Paris

As protector of archers and intercessor against the plague, Saint Sebastian was the object of widespread devotion. Since the Renaissance the martyrdrom of Saint Sebastian had been a favorite theme of artists. It gave them a pretext for exalting the male nude, with all the implications of such a subject. Around 1875, while he was still working on a number of paintings of Salome, Moreau undertook another series depicting Saint Sebastian. In this highly elaborate study the artist has chosen a contrapposto aimed at enhancing the delicate modeling and the somewhat indeterminate sexual characteristics of the adolescent martyr, who is supported in his suffering by an angel.

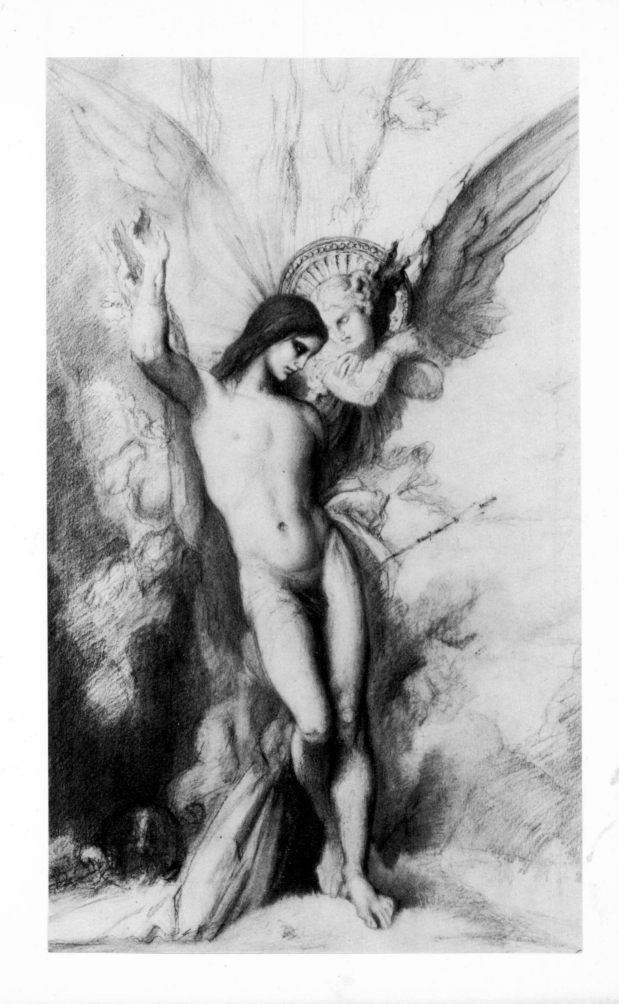

his youthful study for a painting in the Musée de Lille entitled *Autumn*. The painting itself is fairly insignificant, while the watercolor study is captivating; it is freely drawn in pen and ink with the lively strokes characteristic of many of his earliest sketches. He has then gone over it with a transparent wash of brown and red, to symbolize the intoxication of this woman and the little Bacchus caused by the juice of the grapes she crushes in her hand. Is it right to refer to such a picture as a study? We might also call it a "souvenir," a variation on the subject which the painter would have kept by him while working on the painting. The same might be asked of other watercolors that we have considered in this book—perhaps wrongly—as preparatory studies for oil paintings; even though Moreau may have painted them as replicas of the works he sold, destined for his future museum.

The Master of Poetry

From 1865 Moreau began to put the technique of watercolor to more ambitious use. Besides his costume studies for theater and opera—such as the long series for Gounod's *Sappho*—he produced some very highly finished watercolors which he called "designs for enameling." Ever since his return from Italy he had been studying the Renaissance enamels he had seen on exhibit at the Louvre. In 1860 he made his first cartoon for an enamel, in which he tackled one of his favorite themes: the myth of Daedalus and Pasiphaë. Moreau's interest in the intricate art of enameling was probably sparked by the painter Frédéric Charlot de Courcy, an old friend from Picot's workshop and his traveling companion in Italy. It was Courcy's ambition, shared by the painter Popelin, to revive the art of enamel, which had been so skillfully practiced during the Renaissance by the Limosins, the Courtois, and Reymond, and which had long since been forgotten. Courcy was a figure painter at the Sèvres porcelain factory, where an enamel workshop had been set up in 1845. Between 1865 and 1870 Moreau painted several watercolors for him, and these were transposed onto enamel and exhibited at the Salon. Sadly, none of Courcy's enamels have survived.

In 1885 two other enamel workers, Paul Grandhomme and Alfred Garnier, were introduced to Moreau, and for them he did some watercolors in which the somber browns, dull blues, emerald greens, and mauves displayed to best advantage the brilliance of the enameler's colors. Grandhomme and Garnier used a dozen or so of Moreau's watercolors for translucent enamels, and a few of these precious objects have survived. These can be seen at the Musée des Arts Décoratifs in Paris and at the Musée d'Orsay.

In 1865 Moreau painted for Courcy a watercolor with gold highlights entitled *The Peri*. It is drawn with the precision of a miniature, and no doubt with the aid of a magnifying glass. This was his first excursion into the imaginary world

29
GIOTTO (enlarged)

Watercolor with gouache highlights over pencil drawing C. 1882. 20.3 × 22.1 cm. Signed bottom right in gold and red: *Gustave Moreau;* bottom left in gold: *GIOTTO.* Cabinet des Dessins (Hayem Bequest), Musée du Louvre, Paris

During his stay in Italy, and again in 1862, when the Campana Collection—rich in early Italian works—came to Paris, Moreau spent hours on end studying the pre-Renaissance masters. This watercolor, which uses the figure of a shepherd from his painting *Orpheus* (Louvre, Paris), of 1865, is an homage to Giotto, the greatest of the "primitives." According to Giorgio Vasari, Giotto was first noticed by Cimabue when, as a young shepherd, he would draw sheep in the dusty soil. This is the scene depicted here, with emphasis on the rapt face of the herdsman who was soon to become the glory of the Florentine school. Accordingly, the city can be seen in the distance.

64

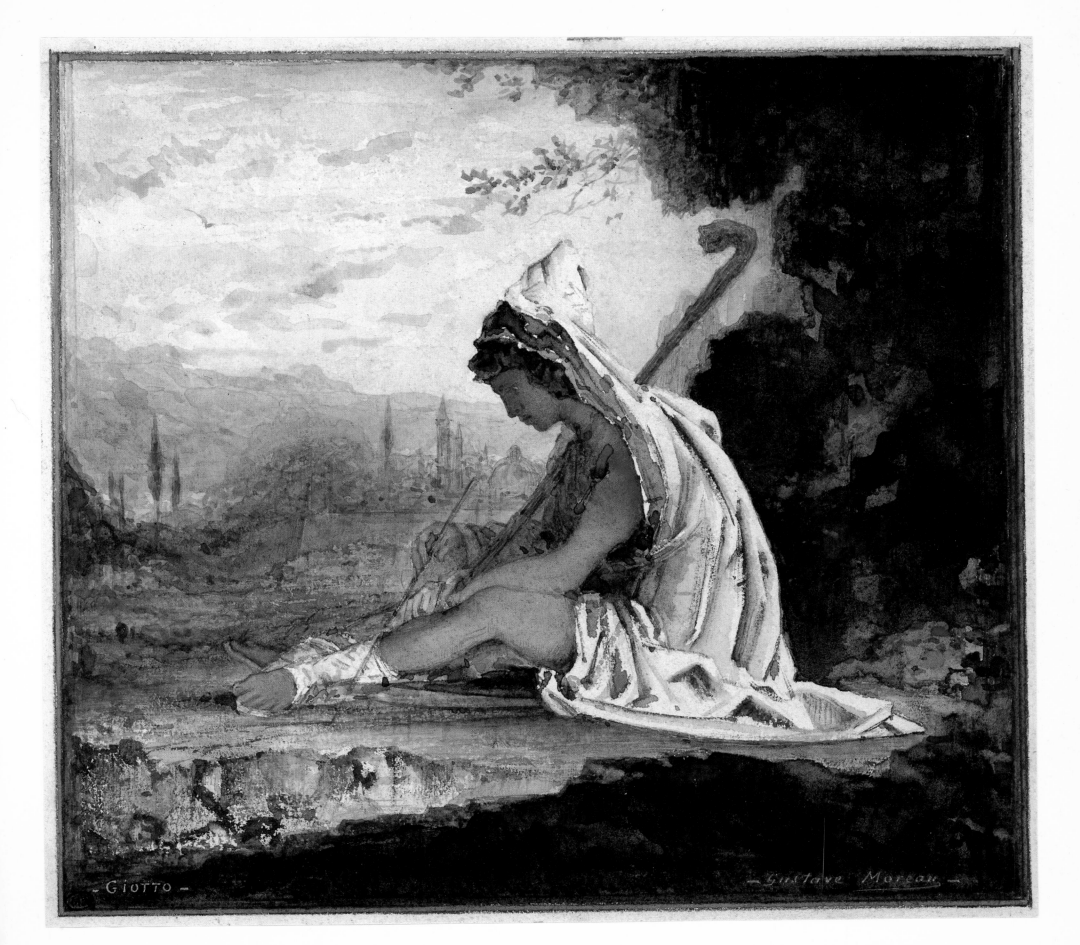

GIOTTO Gustave Moreau

30
Centaurs Carrying Off a Dead Poet
(enlarged)

Watercolor with gouache highlights on
beige paper. C. 1890. 11.5 × 24.5 cm. Signed
bottom right: *Gustave Moreau*. Gustave
Moreau Museum, Paris

The centaurs, half man and half horse,
denizens of forest and mountain, represent
the beast in man, his instinctive brutality, his
unbridled sexuality. The poet symbolizes the
civilized hero, the spiritual and elevated side
of human nature. These funeral ceremonies
for the dead poet, who was no doubt a victim
of those whom he tried to pacify, stand for
the triumph of the spirit over evil, and of
civilization over barbarism.

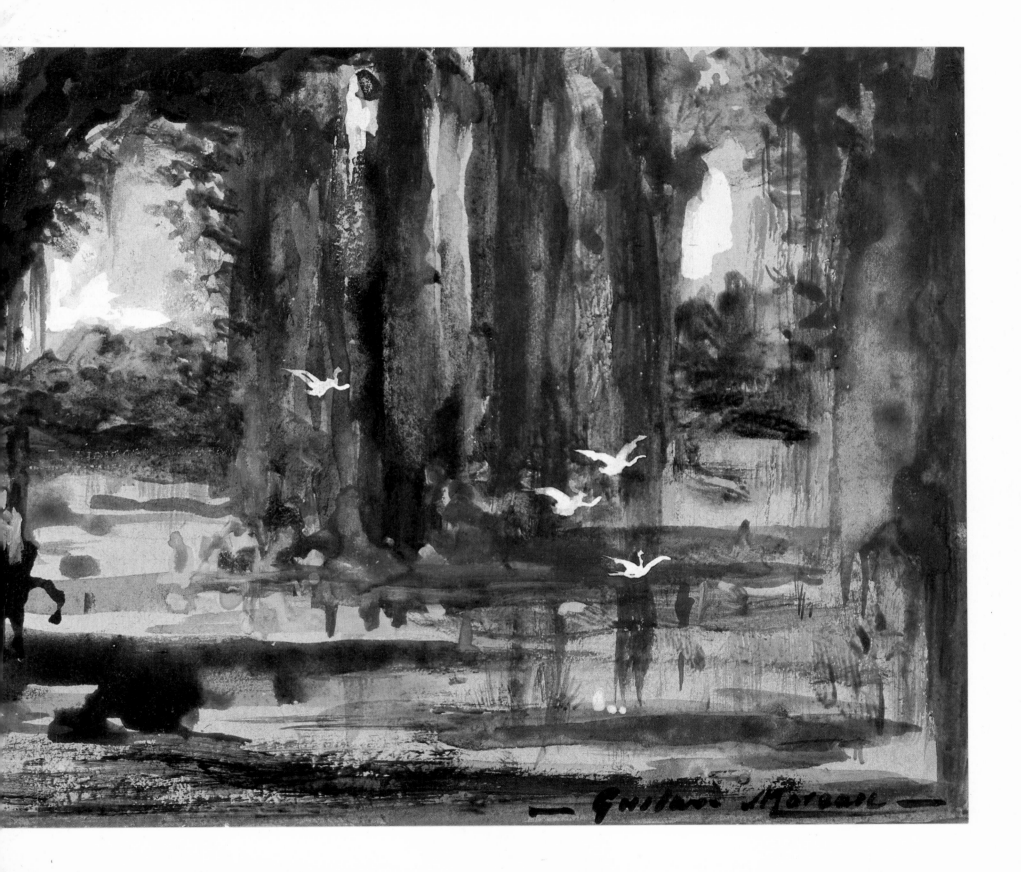

Gustave Moreau

of the Orient, invented on the basis of things he had read, and inspired directly by a small oriental gouache of Persian origin which he had studied at the Bibliothèque Nationale. The picture is devoid of any moral content; it shows the little fairy of Persian mythology, the Peri, rising up into the clouds on the wings of a dragon, having disturbed humanity's sleep with her spells. The artist's objectives are purely decorative: he wants to compete with the richness of oriental miniatures, setting the central figure in a dense arrangement of flowers taken directly from Owen Jones's *Grammaire de l'ornement*. Moreau repeated the theme of the Peri at various times, and it is interesting to compare the watercolor of 1865 with another dated 1881, entitled *Dream of the Orient*. The same little fairy is present in the later work, nonchalantly stretched out on her dazzling mount. But in fifteen years the artist's technical skill has developed: the brushstrokes are more fluid, the colors more luxuriant and the academic floral border of the earlier work has been replaced by a garden of vast, dazzling lotus flowers rising up into the night as though possessed by a sort of febrile excitement.

Throughout his career Moreau often painted watercolor replicas of his most famous pictures for his admirers. However, he was not content simply to copy his own paintings; instead, he translated them into the medium of watercolor, consciously simplifying them and avoiding the glazed effects which sometimes mar his canvases. Although he sometimes retouched his watercolors with gouache, and often gold, he retained their transparency. He favored a light background and luminous, unadulterated pigments—ultramarine, emerald green, yellow, orange-red—and he used the texture of the paper, leaving tiny white points in the areas of brown and ocher (colors that tend to absorb the light). His advice to one particular connoisseur who had just bought several of his watercolors was, "Display them so that they are lit from the left; that will eliminate the small shadows thrown onto the drawing by the grain of the paper, which is bound to happen unless one uses saturated paper."

Comparing Moreau's oil painting with his watercolor versions of the same subject, often painted years apart, one finds that the watercolors—which can be taken in at a single glance—are often more seductive and poetic. In the watercolor copy after the Louvre *Orpheus,* for example, not only has Moreau made various changes in order to avoid the monotony of straightforward reproduction, but he has also simplified the composition, toned down the color, and deliberately rejected the polished look of oil paintings for the Salon.

A significant part of Moreau's work is an homage to poetry, and his paintings at various times celebrated Apollo, Hesiod, the Muses, and Tyrtaeus. Sappho, like Orpheus, embodies poetry. For Moreau Sappho is not the perverse lover of women that she was for Baudelaire, but the sacred priestess of poetry who, before throwing herself from the Leucadian promontory, dedicated her lyre to Phoebus. In the watercolor reproduced here, Moreau shows her prostrate at the top of steely blue crags, richly dressed in a floral robe, her lyre at her side;

31
STUDY OF A LION (detail)

Pencil and watercolor. 1881. 19 × 27.5 cm. Signed bottom left: *Gustave Moreau;* inscribed at bottom: *Jardin des Plantes / 1 Septembre 81 lion du Soudan.* Gustave Moreau Museum, Paris

This is one of hundreds of animal studies which Moreau sketched from life in preparation for his illustrations of the *Fables* of La Fontaine. Moreau often went to the zoo at the Jardin des Plantes, just as Géricault, Delacroix, and the Romantic sculptor Barye —who made some wonderful sketches of tigers—had done. Moreau sought to depict the animals in the attitudes that best expressed their characters. He supplemented his studies from life with sketches made in the Anatomy Gallery of the museum. The animals he drew are found, almost unaltered, in the finished watercolors, where they seem to fit naturally into imaginary settings.

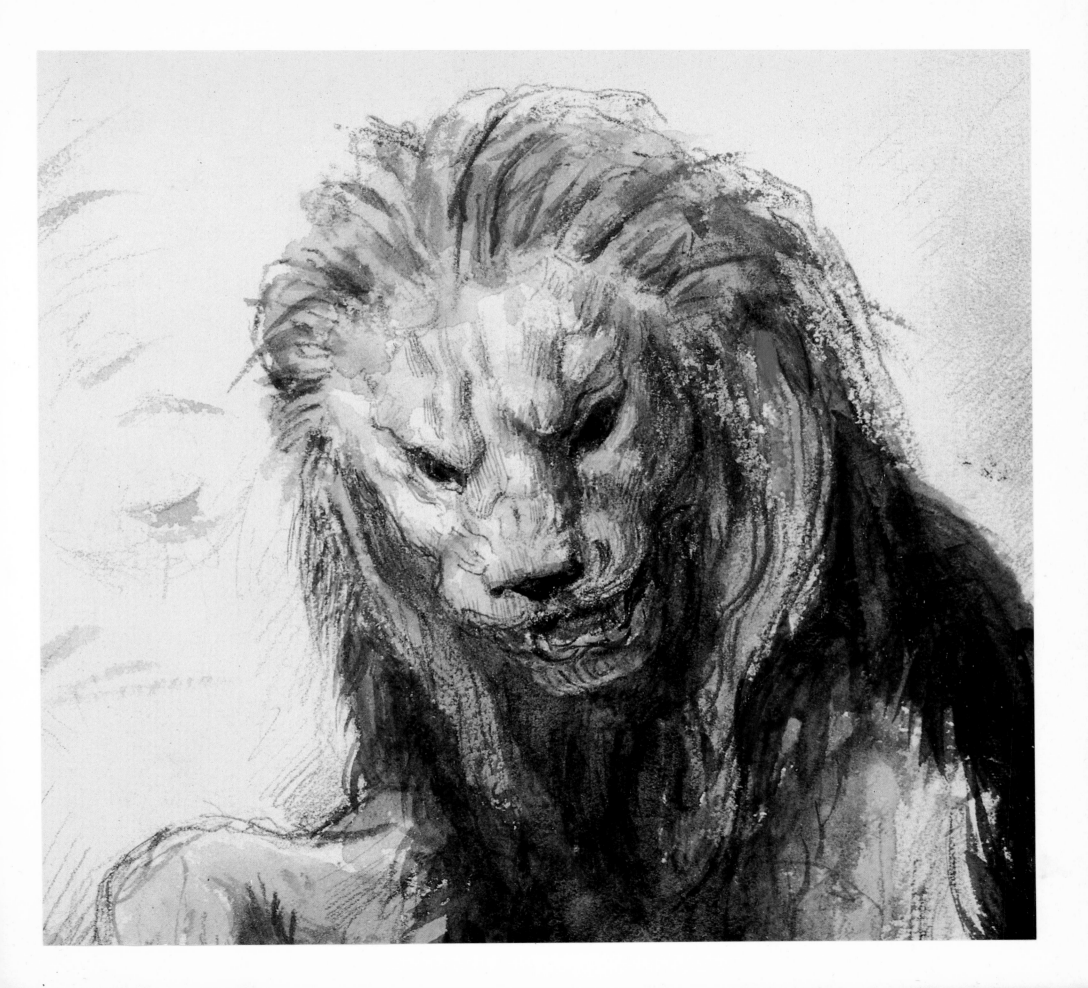

silhouetted against the vast, pearly sky is a blue and gold column surmounted by a winged horse, a symbol of inspiration. It is a work of remarkable delicacy in which the brush seems merely to have skimmed the paper, leaving a light trace of its rich colors.

The Obsession with Salome

By 1875 Moreau was such an accomplished watercolorist that he undertook two works each a yard high which displayed his supreme ability: *Phaeton* and *The Apparition,* both of which were exhibited the following year.

He was working on *The Apparition,* a watercolor, at the same time as the oil painting *Salome Dancing* (Los Angeles County Museum). The figure in these two works appears again in *Salome in the Garden* (1878, private collection). In *The Apparition* she is walking through an arbor carrying the bloody head of Saint John the Baptist on a platter. Moreau was not the only artist to be intrigued by the story of Salome and her gory wedding feast. Since medieval times many painters had represented the daughter of Herodias contemplating with relish the severed head of the saint, his eyes often still half-open. But Moreau was the first to depict the head like this, suspended in the air, eyes wide open, rising from the platter where the executioner had laid it and appearing before the young dancer, whose body is frozen in terror. The strangeness of Salome's vision is mirrored by the fantastic setting. Four other figures are present: the old, prostrate king, whom Moreau describes as "an oriental mummy, tired and emaciated," Herodias staring vaguely, the little musician girl derived from a collection of Indian miniatures, and the turbaned executioner. But they do not see the vision, which is set against the richly wrought mihrab of a mosque in which one can make out the form of a Buddha with a crucifix in his halo. And to make the scene still more evocative, Moreau has colored the flagstones with the stain of blood, though he does not overstate the morbid aspect of the scene as Regnault might have done.

This picture must have made a great impact on the public, especially as Moreau exhibited it at both the Salon of 1876 and the Paris World's Fair of 1878. In the press it was called "a dream, a hallucination, the work of a madman, by the masterly hand of an opium smoker, a hashish eater." The most enthusiastic comment came from the writer Huysmans in his *A Rebours* of 1884.

Never before has a watercolor achieved such an explosion of color, never have chemical pigments in all their poverty produced such gemlike brilliance, gleaming hues like stained glass in the sunlight, such a dazzling display of fabric and of flesh.... Gustave Moreau has derived these qualities from no one. Without a real mentor and with no clear influences, he was

32
DEATH AND THE WOODCUTTER

Watercolor. 1881. 26.7 × 20.2 cm. Signed bottom right: *Gustave Moreau.* Private Collection

La Fontaine presents two versions of this fable: his own and another based on Aesop. Moreau chose to illustrate the second, which enabled him to portray the figure of Death in a far more flattering light than in La Fontaine's version, where she is so hideous that the woodcutter pushes her away. In the text based on Aesop's the poor fellow is more justified in his reaction:

He called to Death, and she came straightway,
Asking what he wanted of her.
"To help me load this wood," said he,
"I shall not keep you long."

La Fontaine

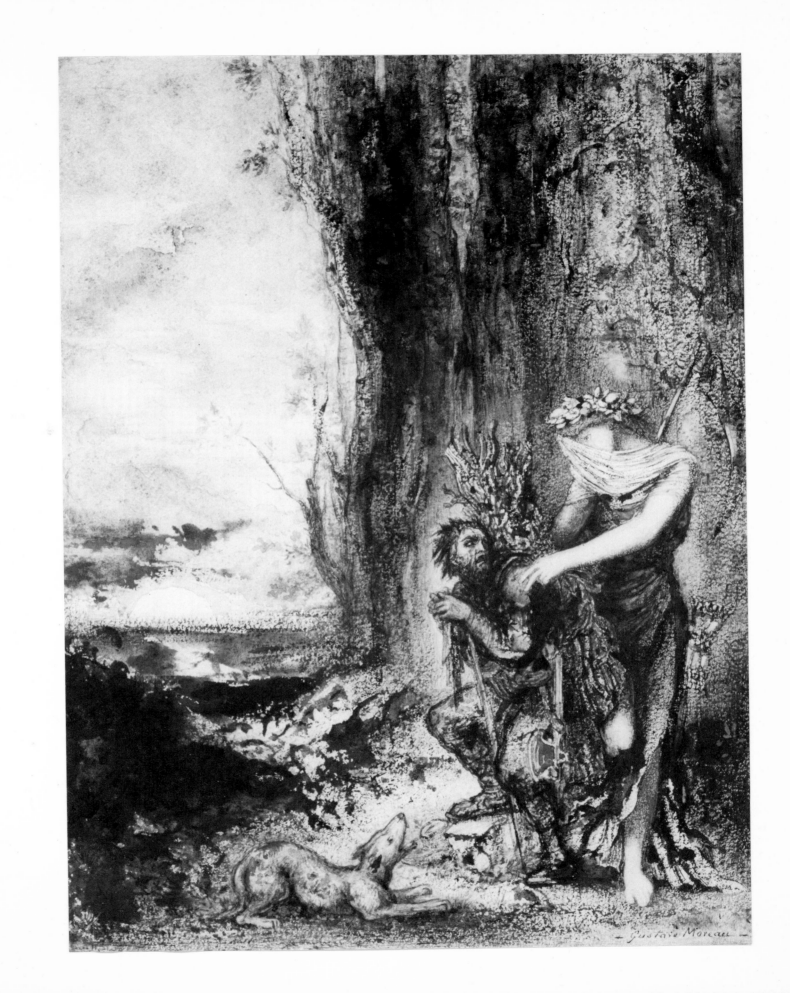

unique in the sphere of contemporary art. He returned to ethnographical sources, to the origins of all mythology, comparing and unraveling their strange enigmas; he combined the legends of the Far East which had been changed by the beliefs of other peoples, and thus he justified his amalgamation of different architectural styles, his unusual combinations of luxurious fabrics, his ominous and hieratic allegories sharpened by the anxiety of a thoroughly modern neurosis. And he remained forever mournful, haunted by the symbols of superhuman loves and perversities, of divine debauchery consummated without abandon and without hope. His learned, despairing works had a remarkable magic, a charm which stirred you to your very core, like some of Baudelaire's poems.

Although *The Apparition* is seldom exhibited today, it continues to fire the imagination of writers; indeed, it inspired one of the strangest short stories by the French writer Alain Robbe-Grillet, *The Secret Chamber,* which he dedicated to Moreau. It opens with a gruesome vision: "First it is a red stain, of a bright, brilliant red, but somber, with deep, dark shadows. It forms an irregular rose with a distinct outline and large, unequal trickles in various directions, dividing, dwindling, and becoming sinuous threads."

The figure of Salome continued to obsess Moreau like no other. To him she symbolized "the eternal woman, a delicate and often fatal creature, going through life—a flower in her hand—in quest of a vague and often frightening ideal, always walking, crushing underfoot everything she encounters, even saints and spirits." Sometimes he depicts her in an enchanted garden, her face innocent, wearing a deep blue robe and gazing lovingly at the head of John the Baptist, whose body lies at her feet, while the horrified executioner flees. Sometimes he transforms her into a contemporary demimondaine in a flimsy dress with long, flowing sleeves, glancing with amusement at the head beside her. But the most unusual version is one in which the figure of Salome is evoked by a few strokes of almost transparent color, her scheming eyes and profile drawn in, her body simply suggested with broad brushstrokes. This masterpiece of spontaneity, in which color is the sole means of expression, caused Moreau to write: "This little watercolor has made it clear to me that I only paint well when I work quickly."

Several of his representations of Salome can be seen at the Gustave Moreau Museum, where Odilon Redon took great delight in them. "Some of them," he said, "are disconcerting for anyone who has tried their hand at watercolor.... Indisputably he is a great watercolorist, a true master, who really understands painting; one of the few of his time."

Redon was even more impressed by another of Moreau's great watercolors: the *Phaeton* of 1878. Moreau exhibited this work as a "scheme for a decorative project." He longed, as we have said, to "master" the wall, as Delacroix and Chassériau had done, and in fact the intention of the *Phaeton* was to rival

33
THE PEASANT OF THE DANUBE

Watercolor. 1881. 27 × 20 cm. Signed bottom right: *Gustave Moreau.* Private Collection

His hairy person
Resembled a bear, but an unkempt
 bear....
This man had come on a deputation from
 the towns
Along the Danube: nowhere was free
 from the far-reaching, all-embracing
Avarice of the Romans.
And so the peasant made this speech:
Romans and Senate, who are come to hear
 my words....
Not intentionally so much as by default
Rome is the cause of our torment.
Beware, Romans, beware
For one day the Heavens might confer
 such misery and poverty on you.
 La Fontaine

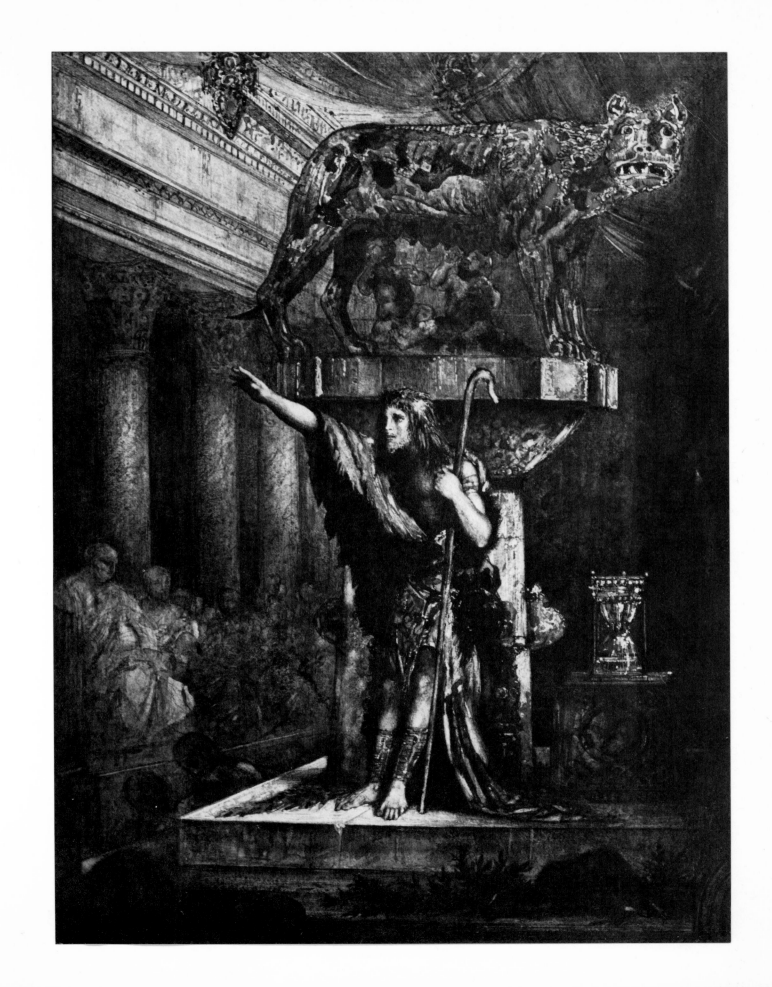

Delacroix's *The Serpent Vanquished by Apollo*, painted about thirty years earlier for the central ceiling of the Galerie d'Apollon in the Louvre. Delacroix's influence is apparent not only in the overall disposition of the painting, but also in the massive form of the serpent surging up through the firmament. It represents the unfortunate mortal stranded in the zodiac, the tiny and powerless prey of Leo and Cancer, who are about to devour him. It was a work of extreme subtlety and stunning color, whose subject and monumentality were ideally suited to decorate the ceiling of a public building.

And Moreau had the opportunity to put just such a scheme into practice when he was commissioned, later on, to decorate one of the rooms of the new Sorbonne with "a picture or decorative painting measuring six meters by three meters." But he turned down this commission, which would finally have enabled him to compete with his friend and rival Puvis de Chavannes, who had just completed his great decoration for the amphitheater. Maybe he would have taken it on had he known what Odilon Redon was writing about him in his diary:

> I don't know which of Delacroix's beautiful studies comes to mind when I look at this dazzling watercolor, whose audacity and originality of vision can be coupled with the works of that Romantic master. Delacroix is more abundant, less restrained; he has applied the power of his imagination to history's most varied subjects. Above all, he is more passionate, and the supernatural light which illuminates all his work sets him apart in Olympus. But in Moreau I see more thorough research, a delicate and sensitive penetration of his own mind. He knows what he wants, and wants what he knows, like a true artist. He is like the writer who hones his work without in any way diminishing the scope of his ideas. His sense of reason guides his imagination. The real subject of this bold *Phaeton* is the representation of chaos. Who could have imagined anything like this? I don't know. Never has the visual rendering of fable been so truthful. In the burst of his thunderclouds, in the daring divergence of lines, in the asperity and dash of his colors, there is grandeur, excitement, and a sense of wonder. I defy you to find a comparable illustration of the fable, or to find within the stern style of academicism a spirit able to bring antiquity to life in this way, with such total freedom and in a form which is at once passionate and restrained.

34
THE TOWN RAT AND THE COUNTRY RAT

Watercolor. White highlights over pen and ink drawing, on tracing paper. 1881. 28.5 × 21.5 cm. Gustave Moreau Museum, Paris

Rapidly executed, this sketch—which may be a "souvenir" that Moreau intended to keep—demonstrates the artist's virtuosity and his ability to capture the essence of the situation. His main object was to describe, by means of his agitated drawing, the hurried flight of the two little rodents. La Fontaine had used the phase *reliefs d'ortolans*. As suggested by his client, Roux, Moreau included a richly laden table, thereby giving a free rein to his taste for ornamental richness. Although more highly finished, the watercolor painted for Roux retains the essential qualities of this study.

The Boudoir of Alexandrine

Moreau believed that an artist's personality should be completely dominated by his work, so he led a quiet, almost closeted existence (although he never shirked his social responsibilities). He prohibited the posthumous publication of his writings and photographs. He once agreed to paint a self-portrait for the famous Vasari Gallery at the Uffizi, but he subsequently retracted his offer, saying, "It was conceited of me to presume to take a place among those outstanding artists of the past, those venerable pioneers whose very names fill me with awe." When Moreau died, Henri Rupp, the executor of his will, actually burned some of his more intimate writings. But Moreau's personality was far more discernible through his work than he realized, and his choice of subjects and the mythical and biblical characters he depicted reveal a personal conception of man—and woman. The real significance of this conception cannot be adequately understood, however, without knowing a little more about the artist, not out of idle curiosity but simply to throw light on his work and to deter the misguided judgments of critics and art historians.

Even the casual observer will be struck by Moreau's unflagging celebration of woman throughout his career. Salome, Galatea, Sappho, Pasiphaë, Leda, Helen, Delilah, Cleopatra, Bathsheba, Suzannah, Messalina, not to mention peris, fairies, chimeras, sphinxes, and unicorns. They all appear repeatedly, in both his paintings and watercolors. His work is dominated by the image of woman, often associated with death. Georges Bataille described admirably the mixture of eroticism and violence characteristic of Moreau's work: "The violence of his pictures is restrained. The characters' relative calm conceals an oppressive inertia: they are possessed by death, pain, a desire to kill. Moreau is in fact a painter of passions. His strange compositions are steeped in the violence of death or a stifling sensuality, but always restrained.... He succumbs to the attraction of eroticism, but he cannot get away from death." It would be interesting to compare Moreau's often morbid eroticism with that of Delacroix's *Death of Sardanapalus* or Ingres's *Turkish Bath,* or with the eroticism of Rops, whose overt symbolism is quite unlike that of Moreau.

Sometimes Moreau sees woman as a saint or virgin, inaccessible in her icy beauty, crouched in the depths of a cave, like Galatea enticing Polyphemus, who sees her but cannot touch her, or guarded by ferocious griffons who keep her, in the painter's words, "protected from the reckless ventures of the common people." Sometimes he reduces women to bestiality, as in his chimeras, who join with their chosen beast until they form a single body, or all those heroines whom history or mythology condemned to unhappy love. Only the Virgin Mary and occasionally saints have a positive role in this gallery of unlovely portraits.

This conception of woman was widespread at the time: among Moreau's favorite authors were Alfred de Vigny and Baudelaire, notorious misogynists. Bourdeau—the first to make a French translation of the works of Schopen-

Watercolor. 1881. 29 × 19 cm. Signed bottom left: *Gustave Moreau.* Gustave Moreau Museum, Paris

The peacock once complained to Juno.
"Goddess," he said, "you know
What good reason I have to moan and
 groan.
The voice you've made peculiarly my
 own
Is abhorrent to all nature,
Whereas the nightingale, that puny
 creature,
Has a song so clear and ravishing
That he's the star attraction of the spring."
Angrily Juno replied:
"Envious bird, you should keep quiet!
You from whose shoulders
Hangs such an iridescent riot
Of silken color, you who strut in the pride
Of your magnificent tail
That seems a jeweler's showcase
 to beholders.
Are you jealous of the nightingale?"
 La Fontaine

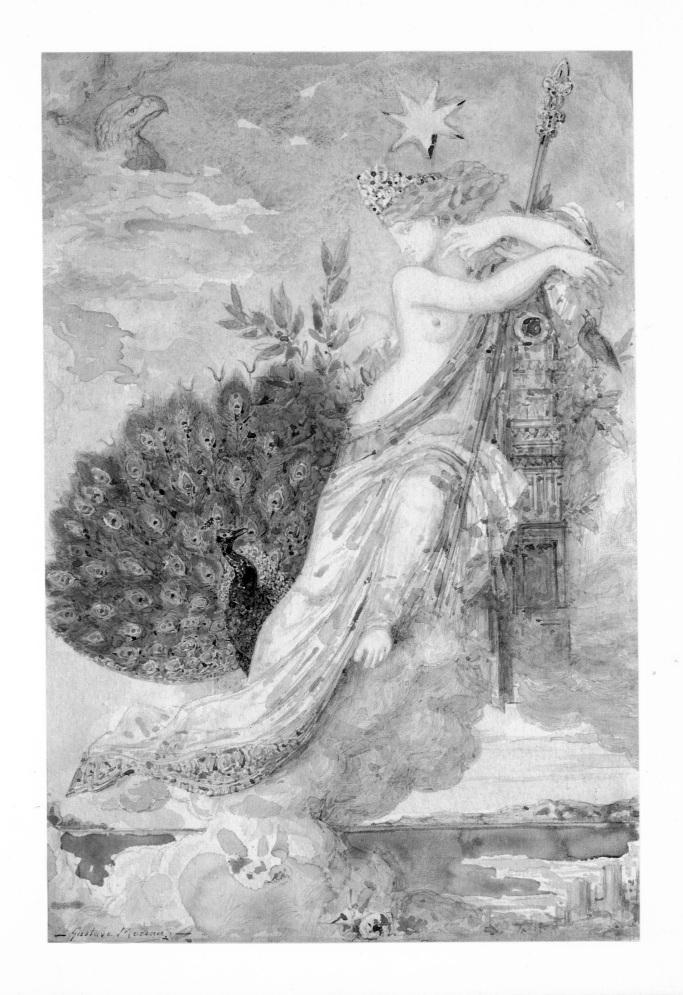

hauer, which reduced love to mere procreation—once sent him the *Pensées et fragments*, whereupon Moreau thanked him by sending him a beautiful drawing of Helen, whose loves had unleashed the Trojan War. Moreau's conception of women is generally attributed to his lifelong celibacy and the constant presence of a domineering mother whose death, at an advanced age, temporarily plunged him into frantic despair.

In the nineteenth century it was very common for artists and writers to remain single. When Moreau wrote that "marriage stifles the artist," he was simply conforming to a view widespread among artists, and one which did not prevent Delacroix, Chassériau, or Courbet from having an eventful love life. But we have recently learned from the personal writings which escaped destruction that for twenty-five years Moreau had a passionate liaison with a woman about whom we know little more than her name: Alexandrine-Adélaïde Dureux. In 1890 she died, and he dedicated to her memory one of his most moving paintings, *Orpheus at the Tomb of Eurydice* (Gustave Moreau Museum, Paris). "My soul is alone; it has lost its source of splendor, strength, and softness; it cries to itself, everything abandoned, in its inconsolable solitude."

When she died he had a tomb made for her—similar to that of his parents, in which he himself would later be buried—and on the headstone he had their entwined initials, A and G, carved. Henri Rupp, the artist's friend and confidant, described her as an exceptional person. "She gave him her all, and he did likewise. He cared for her devotedly, and at her deathbed he suffered the deepest anguish; he was with her when she drew her last breath. Then he fell into the deep despondency that follows an irreparable loss. The best in him was extinguished."

She was a married woman, a textile worker of humble origin. Perhaps she was one of the demimondaines who haunted the area known as New Athens in search of a rich protector. Moreau introduced her to drawing and watercolor painting, often did portraits of her, and made for her a number of oils and watercolors which constitute an anthology of his work. He rented a nearby apartment for her, and when she died he hung the pictures he had given her in his own home. Out of a sense of respect, Henri Rupp did not transfer them to the Moreau Museum, and they are still hanging in a room that is not open to visitors. (One might imagine that after the death of Moreau's mother, Alexandrine Dureux would have gone to live with him, but there is no evidence to support this.) Hanging alongside photographs of his loved one are various watercolors, some evangelical in subject, like the parables of *The Good Samaritan* and *The Bad Rich Man,* others mythological, like *Hercules and the Lernaean Hydra, Pasiphaë,* and *Leda;* and two fans, one showing three winged maidens in an azure sky, flitting from flower to flower. They constitute an unusual selection of sacred and profane scenes; the former were executed with the devotion and reserve typical of Moreau's New Testament paintings, and the latter would give a psychoanalyst ample material. For example, what was in Moreau's mind when

78

36
THE WOLF AND THE LAMB

Watercolor. 1883. 27 × 19.2 cm. Signed bottom right: *Gustave Moreau.* Private Collection

Man is right: the verdict goes to the strong.
To prove the point won't take me very
 long.

A lamb was once drinking
From a clear stream when a foraging wolf
 came slinking
Out of the woods, drawn to that quarter
Of the countryside by hunger.
 La Fontaine

While remaining faithful to the first lines of La Fontaine's fable, Moreau has captured the spirit of this well-known tale, whose tragic outcome is clear.

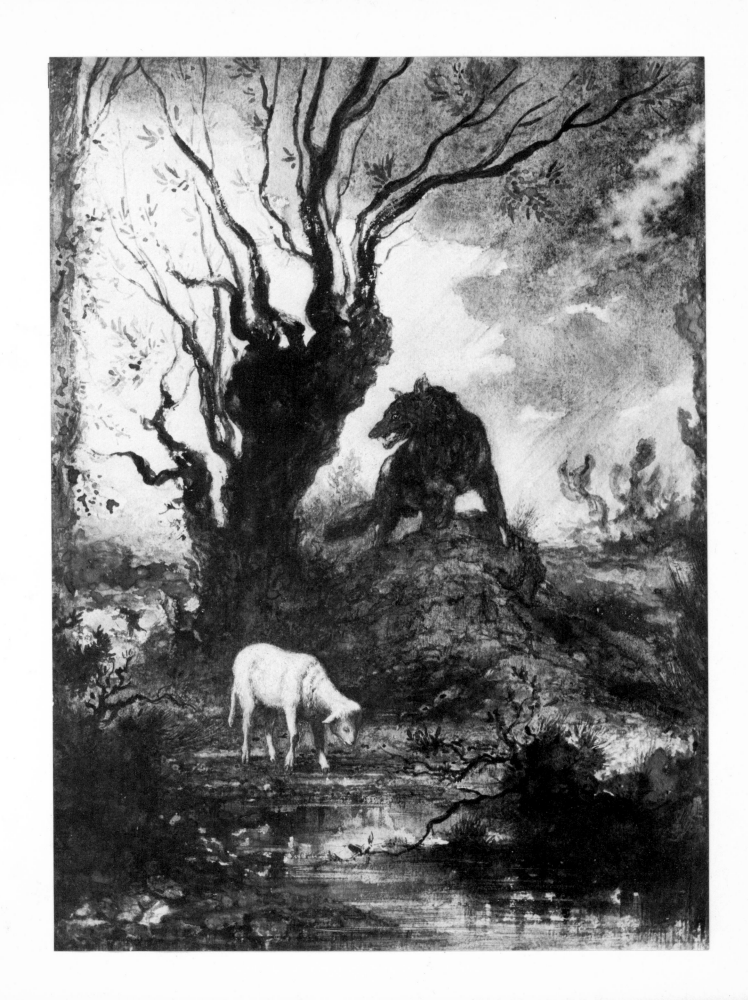

he painted Pasiphaë undressing before getting into the hollow bronze cow which Daedalus had made to attract the white bull (whose silhouette can be seen in the center of the painting)? Just as Baudelaire enjoyed describing the loves of fallen women, perhaps Moreau—whose trade was by definition that of a professional voyeur, making his models pose in any way he desired—projected his erotic fantasies onto paper, both fascinated and horrified by the things he painted.

"Great and bloodless figures," he wrote at the end of his life about Pasiphaë and others, "terrible, grim, and desolate, fatal lovers, mysterious creatures condemned to titanic dishonor, what will become of you? What is your destiny? Where will your great passions be able to hide? What immeasurable sadness you cause to those asked to contemplate so much shame, horror, sin, and sorrow."

But first and foremost, painting should be a joy to the eye, and above all we should admire the rich and magical effects of the artist's brush, which seems to create so effortlessly these visionary pictures where light touches of gouache subtly enhance the watercolor with their brilliance.

The Poet and the Hermaphrodite

Moreau not only celebrated the mystery of women but also, in a more ambiguous way, the beauty of men. The male figures in his work are usually young and slender, and if occasionally they are naked, he covers their sex with obsessively ample and elaborate loincloths which are perhaps more suggestive than total nudity. One of the princes in *The Suitors* is modeled on an antique statuette in the Louvre representing the Phrygian god Attis, whose cult— widespread in Rome during the Empire—required that followers be castrated after the example set by the god, whose costume leaves his genitals exposed. Freudian theory would have plenty to say about his choice of model. Even heroes renowned for their virility, such as Samson or Hercules, are transformed into slim nudes, and the protagonists of many of his watercolors (Ganymede, Narcissus, and Saint Sebastian, for example) support the theory that Moreau was latently homosexual. There is no material evidence of this; however, he envisages the punishment for sodomy in a painting in the Moreau Museum.

Moreau was too worldly to have included only naïvely in his work such androgynous figures that his patrons occasionally had to ask him to make a note of the sex of his heroes, especially the poets. It is well known that he was admired by homosexuals such as Jean Lorrain, Oscar Wilde, Robert de Montesquiou, and Marcel Proust, who had the young Elstir paint some watercolors where we recognize "a poet of a special race who would perhaps be of interest to a zoologist (characterized by a certain asexuality)." He was also admired by reluctant heterosexuals like Sâr Péladan—whom Moreau had little time for

37
THE ANIMALS STRICKEN BY PLAGUE

Watercolor. 1882. 27.2 × 19 cm. Signed bottom right: *Gustave Moreau*. Private Collection

An ill which roused widespread fear,
Created by the Heavens in their anger
To punish all earthly crimes,
The plague (to call it by its real name),
Which could fill Acheron in a single day,
Beset the animals.
Not all of them died,
But all were afflicted:
And none of them were seen to seek
The succor of a dying life.
 La Fontaine

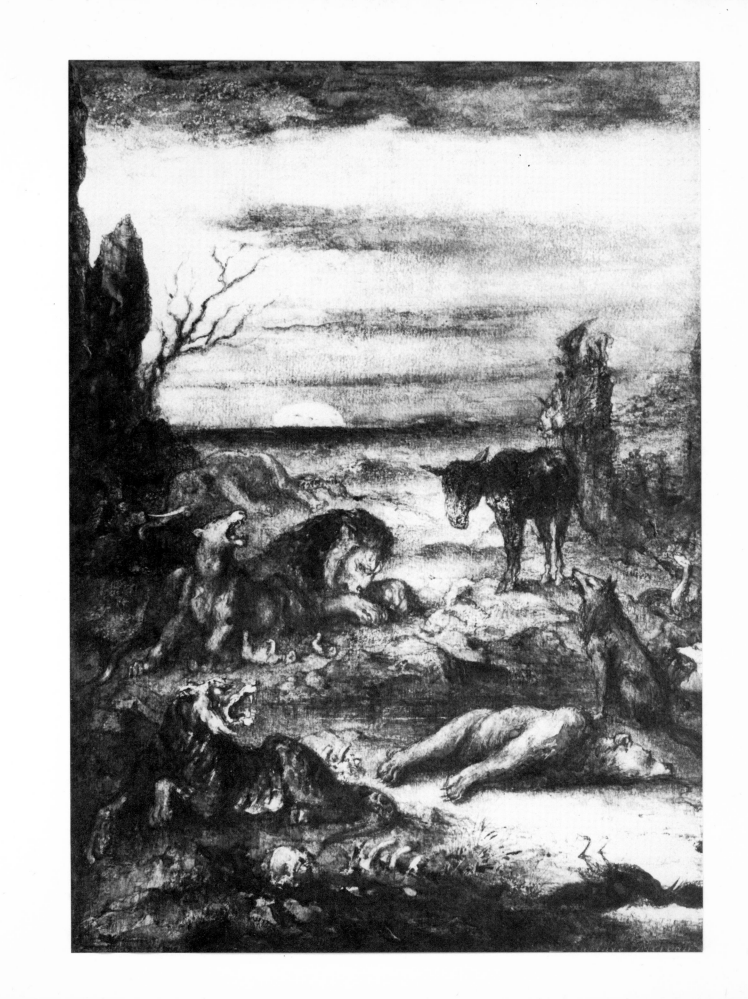

and finally got rid of — and J.-K. Huysmans, who noted, after seeing an exhibition of Moreau's watercolors, that "these different scenes made a single impression, that of repeated spiritual onanism in a chaste body." And yet André Breton, who hated homosexuality, first discovered the allure of women when he visited the Gustave Moreau Museum at the age of sixteen. This demonstrates that different meanings are projected onto Moreau's works according to the spectators' dispositions.

And the heroes of mythology undoubtedly epitomize the deep-rooted impulses in each of us; Freud himself introduced their names into the vocabulary of psychoanalysis. It must be hoped that psychoanalysts studying Moreau's painting do not make the mistake that Freud himself once made in his interpretation of Leonardo da Vinci's *Virgin*.

For Moreau, the real hero was the poet, as an envoy of peace (Hesiod, Apollo), leader of men (Tyrtaeus), and upholder of civilization (Orpheus). No one is better able than the poet to celebrate nature and the seasons, or to sweeten death by his songs. It is the poet who can pacify the savage instincts of those centaurs, half-man and half-beast, that symbolize the animal in man. On several occasions Moreau represented the funeral rites of a dead poet who is carried away by centaurs; clearly the poet is seen as a messianic figure who gives his life for humanity. Baudelaire had already said that the poet was, by nature, androgynous. Moreau's attitude was similar and, in some notes about his *Tyrtaeus* (Gustave Moreau Museum, Paris) he states that the poet must be "young, with a feminine head and classical beauty." In fact, the world created by Moreau excludes overt sexuality. But it has that cerebral eroticism, at once diffuse and omnipresent, which was to become a characteristic of Symbolist literature and painting at the end of the nineteenth century. This would be taken up in the twentieth century by the Surrealists, who would subject their dreams and impulses to psychoanalysis. Certainly no artist anticipated better than Moreau the *fin de siècle* atmosphere which informed the intellectual and social milieu between 1880 and 1900. Mario Praz wrote:

> The figures in Moreau's work are ambiguous; at a glance it is almost impossible to distinguish which of the two lovers is the man and which the woman. All his characters are linked by subtle relationships, like the protagonists of Swinburne's *Lesbia Brandon*. His lovers are almost relations, his brothers almost lovers; his men have the faces of virgins, and his virgins the faces of young men. The symbols of Good and Evil equivocally fuse and intertwine. There is no difference in age, sex, or type. The underlying mood of Moreau's work is incest, the figures he celebrates are androgynous, and the result is sterility. It is exactly this sort of painting, both asexual and lascivious, that expresses so well the spirit of Decadence.

Watercolor 1882. 27.1 × 17.5 cm. Signed bottom left: *Gustave Moreau*. Private Collection

The companions of Ulysses, after ten years
 of trials
Would go where the wind took them,
Unsure of their fate.
They landed on a shore
Where the daughter of the god of day,
Circe, held her court.
She gave them a draft,
Delicious, but filled with a deadly poison.
At first they lost their reason;
Moments later their bodies and faces
Took on the characters of different
 animals,
And they became Bears, Lions, Elephants.
 La Fontaine

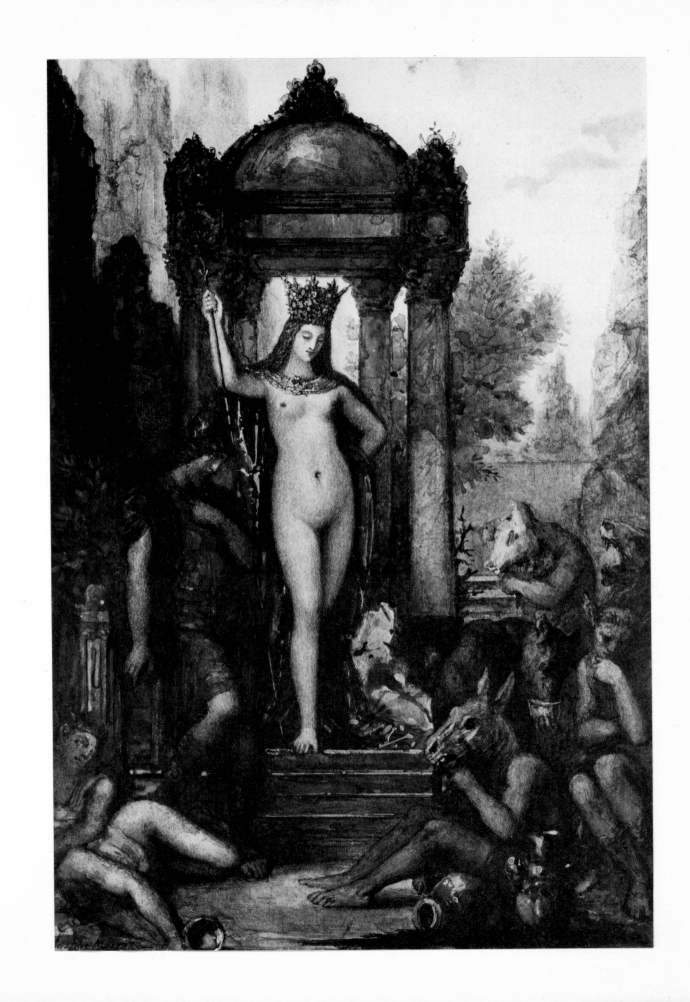

The *Fables* of La Fontaine

Of his own accord Moreau would never have thought of illustrating a literary text. He considered the morals in La Fontaine's *Fables* too simplistic, and besides, to illustrate them one would need to be a competent animal painter, a skill which Moreau felt he lacked. Furthermore, following a given text would mean subordinating one's own inspiration to that of the author. As a teacher, Moreau discouraged his pupils from this sort of exercise. Yet it seems that eventually he enjoyed illustrating La Fontaine, and managed to do so without sacrificing any of his originality.

The idea came from Antony Roux, a rich collector from Marseilles, who so admired Moreau's painting that at the time of his death he owned no less than eighty-five works, almost one fifth of Moreau's oeuvre outside his museum. In 1879 Roux commissioned a number of well-known artists—including Ziem, Baudry, Delaunay, Hébert, Lami, Gérôme and Rosa Bonheur—to paint a series of watercolors illustrating La Fontaine's *Fables,* and he begged Moreau to join them. After some hesitation, Moreau agreed on the understanding that he would limit himself to the more philosophical stories, featuring people rather than animals. La Fontaine's 250 fables afforded him plenty of choice. Roux, for his part, proposed fables that would give ample scope to Moreau's imagination, among them *The Allegory of the Fable, Phoebus and Boreas, The Lovesick Lion, The Mouse that Changed into a Woman, The Two Friends, The Dream of a Mogul Dweller, Death and the Woodcutter, The Peasant of the Danube, The Oyster and His Suitors, Fortune and the Child, The Town Rat and the Country Rat.* To illustrate these, Moreau could produce variations on his own motifs. For example, in *The Allegory of the Fable* he depicted a Peri mounted on a hippogriff, holding the grimacing mask of comedy and a thonged whip in her hands; and in *The Lovesick Lion* he painted a replica of Salome. When animals had to be included, it was either the noble species common to history painting, such as lions and dogs, or everyday creatures like mice and rats, which were readily available for study.

In *Death and the Woodcutter* Moreau depicts a poor bearded fellow turning fearfully toward the slender figure of Death, who appears to him in the form of a beautiful woman, her face veiled. She clearly resembles the figure who appeared twenty years earlier in *The Young Man and Death,* and she is so seductive that one wonders why the fellow hesitates to follow her. But it was *The Peasant of the Danube,* a more serious fable, that really caught Moreau's imagination. He attached particular significance to this moralizing tale: "I have placed this savage at the foot of the she-wolf suckling Romulus and Remus, taken from the antique. A monument to the greatness of Rome, she gives her milk freely, but Rome with its Senate is less generous to its conquered territories. The mournful peasant stands beneath her, and with a sad gesture, remembering his own land of which he is ambassador, he describes the misery of his people to these potbellied and complacent Romans. What an almost Shakespearean

39
BATHSHEBA

Watercolor with gouache highlights. C. 1885/86. 59.2 × 41.5 cm. Signed bottom left in gold: *Gustave Moreau;* bottom right in gold: *BETHSABÉE.* Cabinet des Dessins (Hayem Bequest), Musée du Louvre, Paris

Bathsheba sits on a terrace overlooking a garden of green and yellow fronds, combing her hair. The artist has given her oriental features and an ample figure. The blue form of David's palace rises up against a background of dark green cypresses which stand out against the pale sky. This sumptuous watercolor, clearly inspired by Rembrandt, is treated in the manner of an oil painting, which gives it a certain heaviness and prevents it from being truly seductive. Here Moreau has failed to respect the intrinsic nature of watercolor, which should be lighter and more transparent.

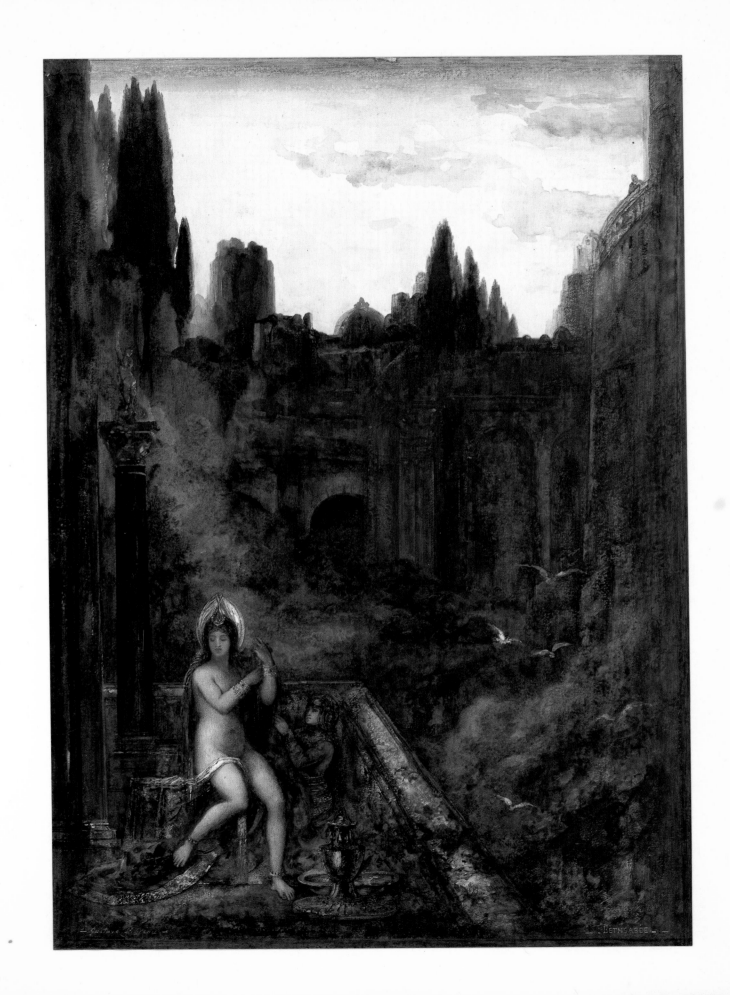

contrast to see this timid faun dressed in animal hides, at the foot of the allegorical beast, speaking to ostentatious and luxury-loving decadents. At his side is an hourglass, showing that time is running out both for the gathering and for mankind." This watercolor could almost have been painted by Gérôme, who was a fine watercolorist and often depicted scenes from Roman history; but Gérôme would not have imbued the scene with such weighty symbolism.

Roux continued to besiege Moreau with new suggestions, and as he went along the artist's illustrations became increasingly free in terms of handling and color. Other painters had illustrated these fables using an almost photographically precise technique; Moreau chose a more relaxed style which, as he wrote to Roux, enabled him "to treat each subject invariably by innuendo, in terms of both idea and execution. It is audacious enough to risk misrepresenting La Fontaine's outstanding genius by translating his inspired verse into another medium, without weighing it down with an excess of gravity and pedantry."

The Town Rat and the Country Rat is a good example. Antony Roux suggested that Moreau use "the Louis XIII style, which would give you the opportunity to include all sorts of curios, precious stones, and gold, in the manner of Benvenuto Cellini." But instead of the meticulous work he expected from Moreau, he received a very loosely handled watercolor, sumptuous, certainly, but breezy in treatment, as though the artist had wanted to use his spirited style of drawing to translate these two lines: "The country rat scurried off / His playmate followed after." The study in the Gustave Moreau Museum is in fact more expressive than the finished watercolor; the confusion of the scene and the hurried flight of the little rodents is conveyed by random hatching and the arrangement of the colors. In *The Miser and the Monkey* Moreau draws on Rembrandt's *Holy Family* (Louvre, Paris) for the effects of light and shadow in the old man's cave, where he sits night and day, "ceaselessly counting and calculating."

In 1881 the three hundred watercolors that Roux had commissioned from different artists were exhibited at the Cercle des Aquarellistes, and it was the twenty-five by Moreau which roused the most public interest. Edmond de Goncourt wrote in his *Journal* of May 15, 1881, "They are strange, these watercolors by Gustave Moreau; they seem to glow like the treasures of the *1001 Nights*." Their success persuaded Roux to commission the rest of the series from Moreau alone, who by this time was convinced that La Fontaine's *Fables* were almost as rich in inspiration as Ovid's *Metamorphoses*. Thus between 1881 and 1885 Moreau painted almost forty more watercolors for Roux.

As he could no longer avoid the introduction of animals into his illustrations, he started to pay regular visits to the Museum of Natural History to learn about the morphology of animals and to draw them from life. "I am not sufficiently familiar with the behavior of these animals, nor even their anatomy," he admitted to Roux. "I expected to master it in just a few days, but it has taken me a whole month of hard work in the Jardin des Plantes." In his earlier

40
THE SONG OF SONGS

Watercolor with gouache highlights. 1893. 37.5 × 19.5 cm. Signed bottom left: *Gustave Moreau;* bottom right: *Cantique des Cantiques.* Ohara Museum of Art, Kurashiki, Japan

One of Moreau's first Romantic paintings treated the subject of the Song of Songs (Dijon Museum). It illustrated the verse in which the young girl is delivered up to the soldiers' brutality. Forty years later he illustrated another scene from the same book: here the Shulamite, a sullen Semitic princess dressed like a Salome or a Delilah, goes to join her husband. But despite its extravagance, the artist is not entirely successful in conveying the ardor which should enflame the girl.

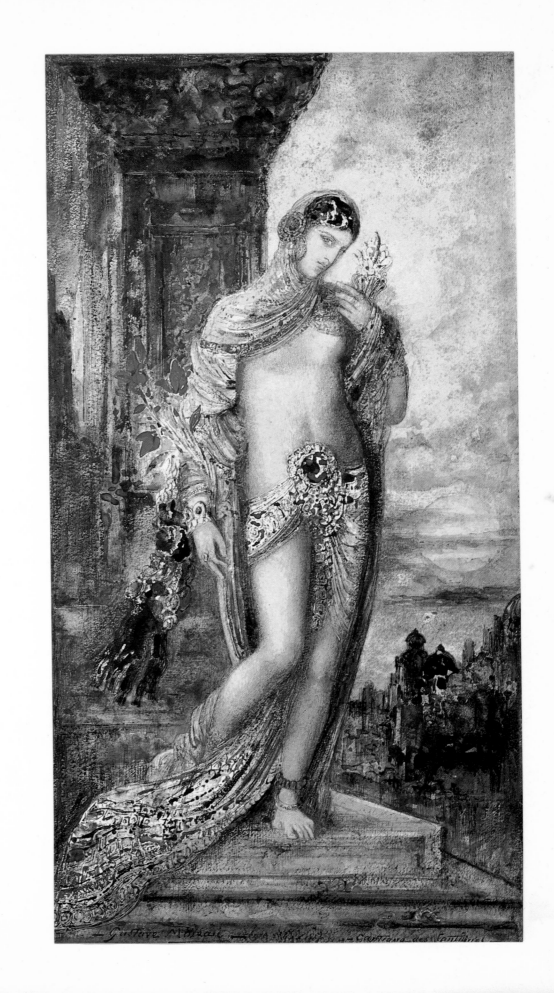

illustrations the animals still fell within the tradition of history painting; now he was no longer content for them to play a secondary role. "For this new series," he wrote to Roux, "you required—quite rightly—real, lifelike animals with all their idiosyncrasies; and to achieve that I have had to start again from life.... I'm up at 5:30 and arrive at the Gardens by 7 o'clock—no pause for rest—with lunch and a little flask of watered down wine in my pocket." And so, like Géricault, Delacroix, and Barye, who had also come to draw the deer in the Jardin des Plantes, Moreau became a competent animal painter. He seems to have taken real pleasure in sketching them in their most typical attitudes, seeking—almost like a photographer—the pose which best expressed the animal's character and the role it played in a particular fable. He made drawings or watercolors of monkeys, lions, elephants, stags, foxes, leopards, bears, rhinoceroses, wolves, peacocks, vultures, storks, and tortoises. He even studied their skeletons in the Gallery of Comparative Anatomy.

From then on he would include them in his often wild and gory landscapes, just as he had seen them in their barred cages. All the pride of the peacock with "a rainbow of a hundred different silks round her neck" is captured in *The Peacock Who Complained to Juno,* and an overwhelming sadness—echoed by the bare desert landscape—pervades *The Animals Stricken by Plague.*

In *The Wolf and the Lamb* Moreau has combined two scenes: above lurks the wolf, terrifying and masterful, his cruel eyes glittering, beside the twisted branches of a willow; below is the innocent white lamb in a little valley, drinking from a clear stream. We can predict the outcome. The same sense of drama fills *The Horse that Wanted its Revenge on the Stag,* in which the foreground is dominated by the bloody remains of a deer.

Some of Moreau's illustrations display the artist's sense of humor: *The Frog that Wanted to Be as Big as the Ox; The Companions of Ulysses; The Council of Rats; The Frogs Asking for a King; The Miller, His Son, and the Donkey.* But on the whole Moreau's artistic temperament was better suited to tragic or philosophical stories.

Between 1879 and 1885 Moreau illustrated sixty-three fables, not including the watercolor for the frontispiece. Sixty-two of them are still preserved in a private collection; one is in the Moreau Museum, together with all the preparatory studies. Moreau was paid 1,000 francs each for the first twenty-five, and 1,500 francs for the remaining thirty-nine, so that he earned 83,500 francs in all (at that time a state official started on a salary of 1,500 francs per annum, and a higher official earned between 15,000 and 20,000).

Félix Fénéon, the famous critic of Post-Impressionism who "discovered" Seurat, reproached Moreau for accepting such a large fee from "an old Marseilles investor; for although the watercolors are sumptuous, the scheme will prove compromising." But Fénéon, usually a more perceptive critic, was judging the watercolors according to criteria which had nothing to do with art (he was annoyed with Moreau for having agreed to Roux's request that he work with

41
GANYMEDE

Watercolor with gouache highlights. C. 1890. 24 × 35 cm. Signed bottom left in red: *Gustave Moreau.* Gustave Moreau Museum, Paris

Some interpretations of the myth of Ganymede maintain that it is a moral allegory representing the superiority of the spirit over the body, whereas others hold that it symbolizes the love of men for boys. (In the myth Zeus, in the guise of an eagle, picked out the most beautiful mortal to be his cupbearer on Olympus.) Moreau, inspired by a Michelangelo drawing, depicts the moment when the consenting adolescent is carried off by a powerful eagle, but he avoids any homosexual innuendos. Ganymede, the subject of the scene, can scarcely be seen, and the vast ocher setting is dominated by the flight of the eagle.

academic painters on the series); in fact, Moreau's work was never more natural and lifelike than here. The series is not only a landmark in the history of watercolor, but is probably the most remarkable of any artist's illustrations of La Fontaine's *Fables,* from Oudry and Carle Vernet to Grandville and Doré.

From Color to Abstraction

In 1886 Moreau's *Fables* were exhibited at the Goupil Gallery in the rue Chaptal, Paris, together with seven other large watercolors, which were so elaborate in their color and so opulent, with thickly applied gouache, as to overpower the intrinsic nature of watercolor. The *Bathsheba,* for example, is too heavy to be truly seductive; indeed it has more in common with oil painting than with watercolor. This exhibition was the only one-man show of Moreau's work in his lifetime, and it endeared him still further to his small following. In response to Moreau's exhibition Huysmans, who was disgusted by the era of money and mediocrity in which he lived, proposed an answer to the theory of the influence of milieu which Taine had just disseminated in his *Philosophy of Art.* He maintained that the milieu, rather than forming an artist, roused in certain individuals feelings of hatred and revolt. "It creates among shamefaced Frenchmen figures like Baudelaire, Flaubert, Goncourt, Villiers de l'Isle-Adam, Gustave Moreau, Redon, and Rops—exceptional personalities who look to the past and, disgusted at the promiscuity of their own age, throw themselves into the abyss of bygone times and into the tumultuous void of dreams and nightmares." Even if this theory is no more justified than that of Taine, it expresses Moreau's attitude perfectly, for toward the end of his life he had come to hate his age, and tended to close himself off from the world in the solitude of his work, isolating himself in a sort of mysticism which gradually led him to attach a Christian meaning to the enigmatic myths he painted.

As a rule, artists tend to simplify their style and palette as they grow older, but Moreau's late works display an increasing complexity and such heavy impasto that they recall the techniques of enameling. While the paintings made to be sold are all detailed and meticulous (the best example is *Jupiter and Semele,* which was given to the Moreau Museum by its purchaser), most of the works in the museum, which he painted for himself, are almost expressionistic in their use of color, and they become less and less figurative. It is difficult to establish a chronology for those of his paintings and watercolors which appear to be later than 1890, but gradually the forms become less distinct, and the artist becomes more interested in color and its associations.

In this respect, Turner is the only nineteenth-century artist who can be compared with Moreau. The aims of these two artists are perhaps comparable, and although their work is so very dissimilar, art historians often apply the same

42
THE CHIMERAS (detail)

Watercolor with gouache highlights. C. 1884. 20 × 28.5 cm. Gustave Moreau Museum, Paris

Very rapidly sketched, this highly colored work is first and foremost a Romantic evocation. The three phantomlike women float through space, their robes flowing behind them, as though projected by an irresistible force toward some Sabbath, "in pursuit of an elusive and unattainable chimera." Apart from the sketchy forms of the women, the watercolor is almost abstract and in no way relates to the oil painting of the same subject.

terms to both. In fact Edmond de Goncourt, who was acquainted with Moreau and greatly admired him, describes in his *Journal* of August 12, 1891, a visit to the collector Groult, who had just acquired a painting by Turner (whose work was then hardly known in France). "This is one of the ten paintings which have given me real joy. It is painted in gold fused with purple — craftsmanship which stunned Moreau; he was struck dumb at the sight of this picture by a painter whose name he didn't even know. Ah! this *Salute*, the Doge's Palace, the sea, the pink, transparent sky, painted with all the brilliance of precious stones! And the color, applied in torrents and tears like glazes on Far Eastern pottery. To me, it seems like the work of a Rembrandt born in India." Goncourt suggests that this was the first time Moreau had seen Turner's work, though this is unlikely since exhibitions showing Turner's work had aroused considerable interest before 1890. Maybe the *Salute* stimulated Moreau, but there is no certainty of this.

Either way, Moreau's ideas took him in a very different direction from Turner, and the results were much closer to the abstract painting of the twentieth century.

In 1886 Moreau painted a large watercolor of *Ganymede* inspired by a Michelangelo drawing, showing a poor, naked youth being plucked from the ground by a great bird. In a later version he simply presents the essence of the scene, showing only the swooping eagle in a vast, darkened landscape which is merely suggested with large blocks of color. He takes this process of abstraction still further in *The Temptation of Saint Anthony*. Redon had illustrated Flaubert's famous text (which Moreau had in his library) with an entire series of masterly lithographs. But Moreau gathers all the visions of the saint within a single composition; the saint himself can just be made out toward the center of the picture, and amid the formless brushstrokes one can see, with a little imagination, a serpent, a goat, the head and breasts of a woman, and a large head with a round eye reminiscent of Victor Hugo's ink drawings. But the real subject of the painting could be said to be the color; for despite its title, this is effectively an abstract painting, the pictorial expression of a personal vision. The fact that these

43
THE TEMPTATION OF SAINT ANTHONY (enlarged)

Watercolor with gouache highlights. C. 1890. 13.5 × 24 cm. Signed bottom left: *Gustave Moreau*. Gustave Moreau Museum, Paris

Moreau admired the writing of Flaubert and owned his *Temptation of Saint Anthony*. From this fantastical narrative he could have drawn a series of precise, erudite visions taken from a wealth of religions and mythologies. But he chose to paint the apparitions which obsessed the old hermit in a whirlwind of colors and indistinct, almost abstract, shapes in which one can make out only fragments of various forms.

44
BATTLE OF THE CENTAURS (enlarged)

Watercolor. C. 1890. 15 × 28 cm. Signed bot-
tom left: *Gustave Moreau;* bottom right:
Combat des Centaures. Gustave Moreau
Museum, Paris

It would be hard to identify the subject of this
watercolor had not Moreau given it a title.
To the left one can make out the sketchily
painted forms of two centaurs, face to face,
holding each other by the shoulders. The red
and green areas to the right can perhaps be
interpreted as flying female forms, but
otherwise the figurative content of the work
is minimal.

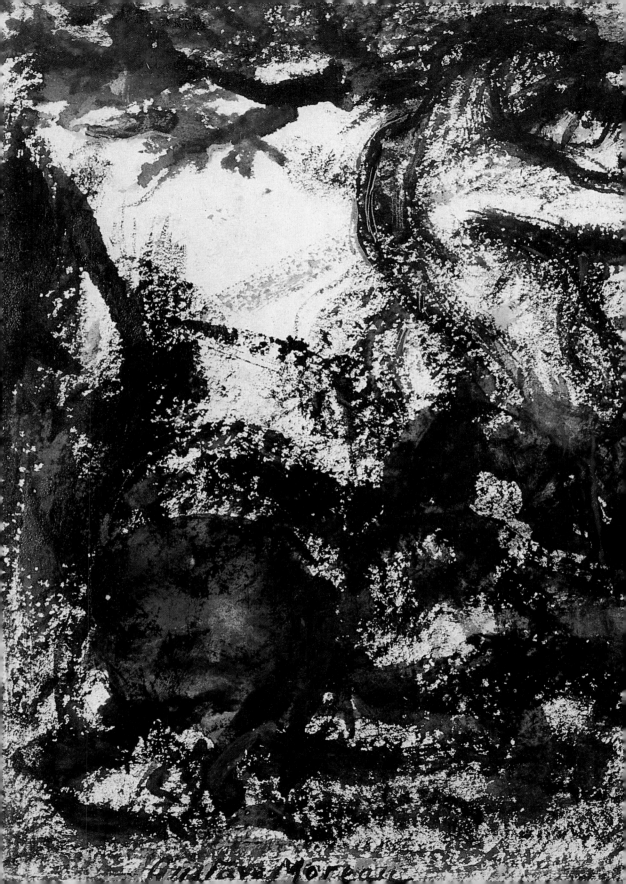

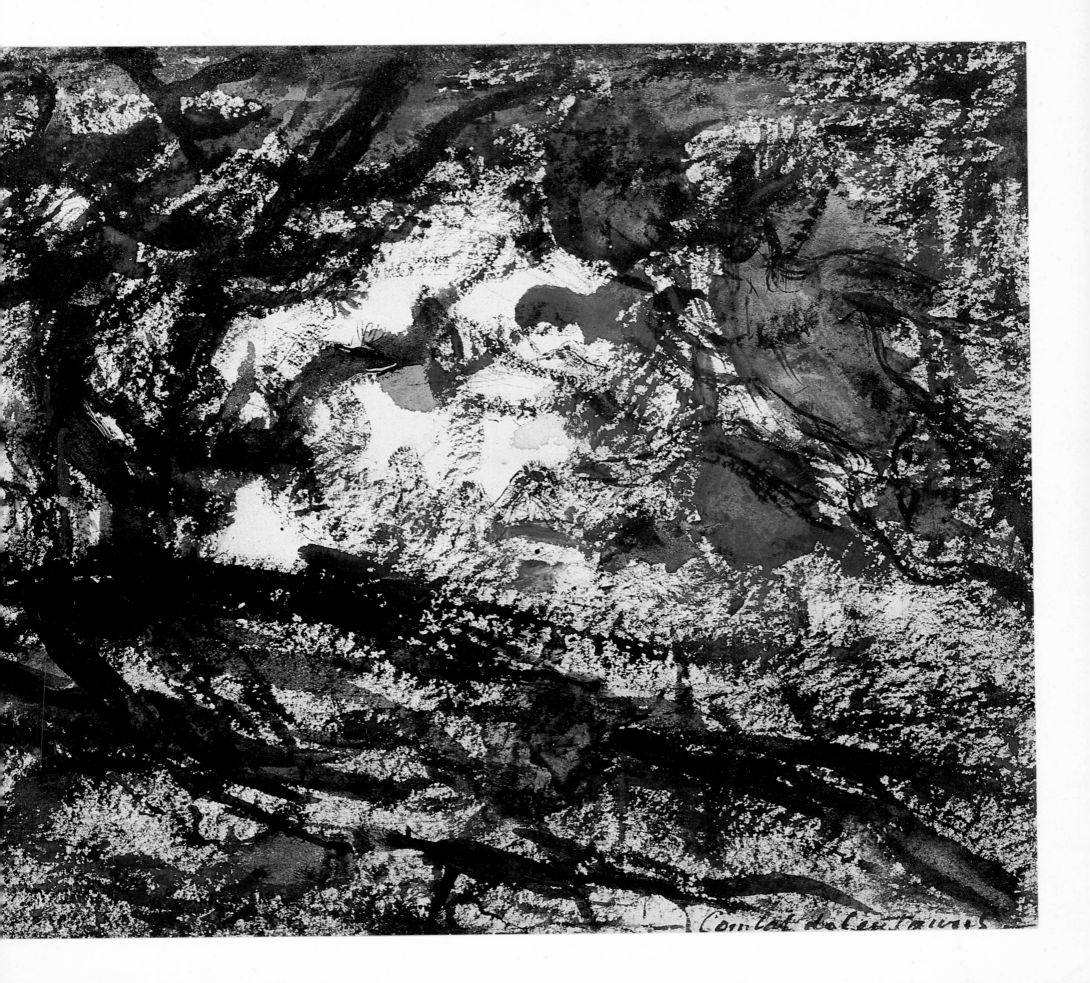

Comlat de Centaures

two watercolors, like the subsequent ones, were signed shows the importance that Moreau attached to them.

The figurative content of the *Battle of the Centaurs*—whose title is actually painted in—is minimal. On the left, two fighting centaurs can be discerned, and, on the right, female figures washed with red and green. But how important is the action, when the most striking aspect of the picture is the random arrangement of brushstrokes? The picture remains a mystery. The same is true of *By the Water's Edge,* though it is not so formless. Who is the central character? Is it Narcissus or a Muse? And who are the tiny figures flying toward him? These works are like colored visions at one remove from the real world. They are the statement of a colorist guided by his painterly instincts. Just before he died, Delacroix wrote in his *Journal:* "Above all a picture should be a feast for the eye." *By the Water's Edge,* like so many of Moreau's watercolors, is an admirable demonstration of this fundamental law of painting, though he had not always given such a free rein to his hand and imagination.

In some of his watercolors, and especially in a group of small canvases, the subjects are unrecognizable. For a time these paintings were shut away in the Gustave Moreau Museum and known only to a few inquisitive visitors; but when the museum was officially opened they were framed and exhibited. In 1906 Robert de Montesquiou recalled that Henri Rupp, the creator of the museum, had wanted everything to be on show (in fact, the work exhibited is only a selection). It seems that "by exhibiting these works, which meant nothing to the casual observer, he intended to demonstrate to artists and admirers his master's avant-garde methods, his right to be numbered among the most radical colorists and even to surpass them in their so-called excesses." Another connoisseur, Léonce Bénédite, who was then a curator at the Musée du Luxembourg (the museum of modern art of that time) said of Moreau:

> His imagination is stimulated by evocative color combinations which evoke
> in his highly impressionable and creative mind sensations that he translates
> into elaborate symbols. What counts here is the magic of his methods and

45
BY THE WATER'S EDGE

Watercolor. 1896. 27 × 37 cm. Signed bottom left: *Gustave Moreau;* bottom right: *Près des Eaux*. Gustave Moreau Museum, Paris

Only the head of the unidentified figure is delineated. Is this Narcissus, or a nymph, reclining by the water's edge? Indeed, without the help of the title one would be unlikely even to notice, for example, the lightly drawn water lily. On the whole the picture remains a mystery, with unexplained elements like the two tiny creatures who seem to be flying toward the reclining figure. Works such as this, which go far beyond representation of the real world, show that before 1900 Moreau had already taken a few steps into the unexplored realm of abstract art.

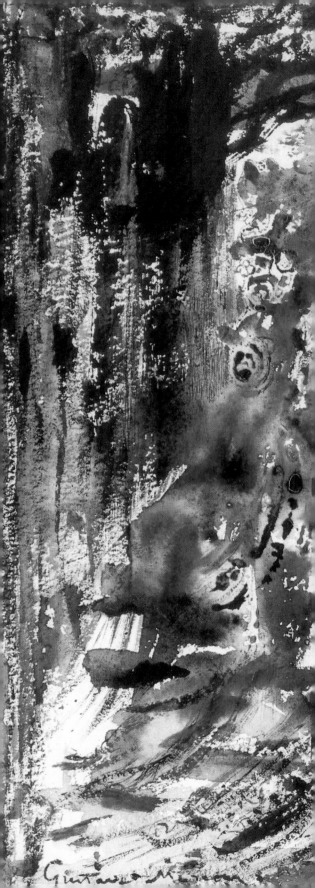

Gustave Moreau

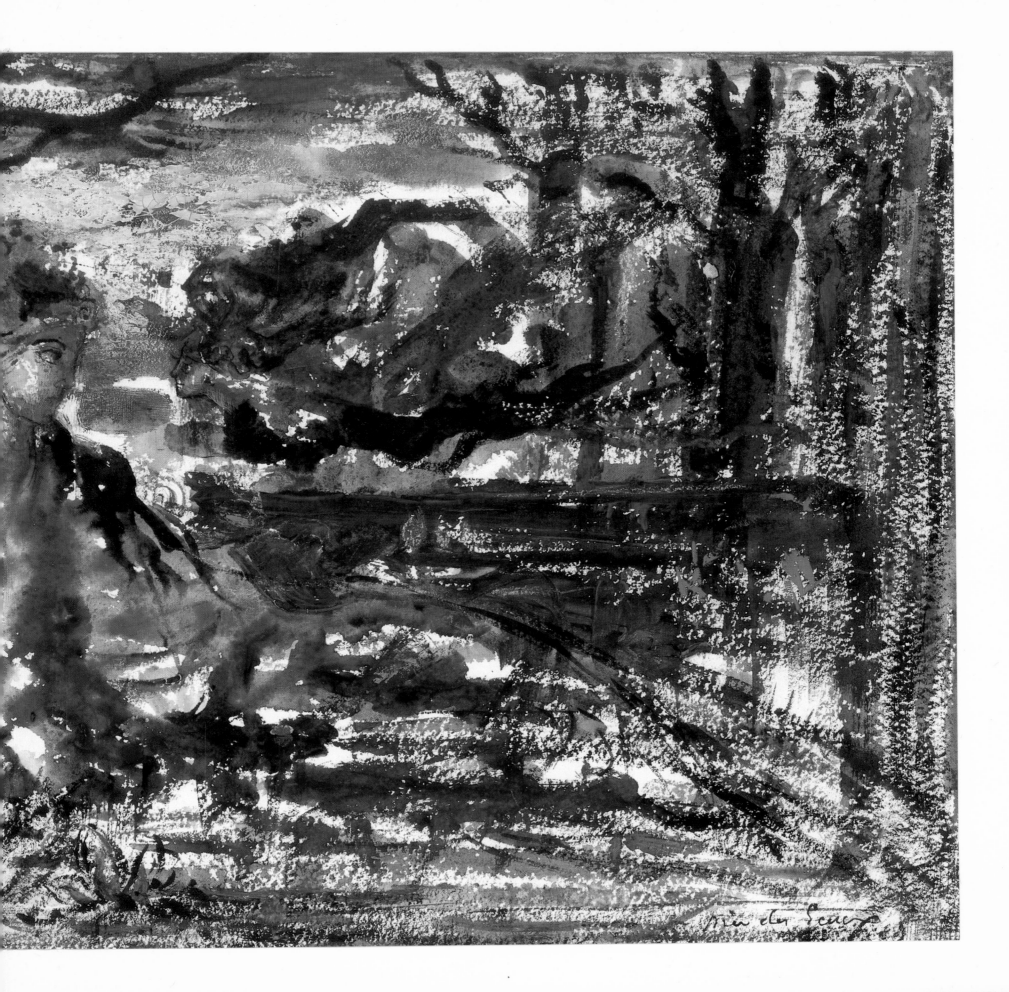

the mystery of his colors. Look at some of the apparently incomprehensible sketches in his studio. All that is required is a few harmonious or contrasting colors juxtaposed on his palette or on a canvas from which he draws his own expressive language. He carefully records these spontaneous, unsolicited thoughts, enfolding them in the feelings they evoke, isolating with his clear vision some aspect of a dream; just like the shape of a dream, gradually and spontaneously emerging from a jumble of gold, amethyst, and topaz, that we see at night with our eyes closed.

These words were written in 1899, undoubtedly on the advice of Henri Rupp, who had helped Moreau choose the works to be shown.

Was this abstraction the result of chance, as one might understandably suppose, or was it the outcome of reasoned thought, as the present writer believes? Certainly we shall never know whether, around 1890, Moreau, a refined and meticulous artist, a member of the Académie des Beaux-Arts along with Bonnat, Gérôme, and Henner, would have been capable of consciously creating these abstract works. In contrast the writings of Wassily Kandinsky, the official founder of abstract art, offer a methodical record of the processes by which he came to paint a nonfigurative gouache in 1910. Certainly without Moreau in mind, he writes that it is "those solitary dreamers who, even if they are regarded with indifference or dislike, build the future of the arts and create indestructible values. If they say little, they are passed by in silence; if they express their dreams with conviction, they are hated."

Although Moreau left various writings about his individual works, he seldom discussed his creative development. However, comments such as this help us to comprehend it: "In literature, as in the visual arts, people generally begin with the form and proceed toward the idea. As a result, they become more concerned with its underlying value." On another occasion he mentions his desire to portray "those inner revelations that come from who knows where." Kandinsky, in turn, evokes embellishment and illumination, and maintains: "The creative artist cannot be satisfied to represent the object as it is; he must try to give it some form of expression. This used to be called idealism."

Equally one could say that Kandinsky, like Moreau (and the other pioneers of abstract art, Mondrian and Kupka), was deeply spiritualistic. He felt that art should above all respond to an inner need. By means of rationalization, Kandinsky deliberately removed all the figurative elements from his painting, leaving "just the abstract elements, pure and naked." For Moreau, conversely, his progress into abstract art was like the final and most personal culmination of his Symbolism.

We cannot claim that he was the founder of abstract art, but he did go to great lengths to distinguish art from nature, and well before 1900 he began to develop a nonfigurative style. In a study on the work of Kandinsky, the art historian Michel Hoog suggests that Moreau may even have influenced the great Russian

46
ABSTRACT STUDY

Watercolor with pencil drawing. 31 × 19.5 cm. Gustave Moreau Museum, Paris

Should this inscrutable watercolor — titled here as it is in the museum — be seen as a study for a painting (though no comparable painting is known), a straightforward experiment with colors, or an abstract variation in which the brush has roved about the paper amid vague pencil strokes, as if the artist had no figurative intentions?

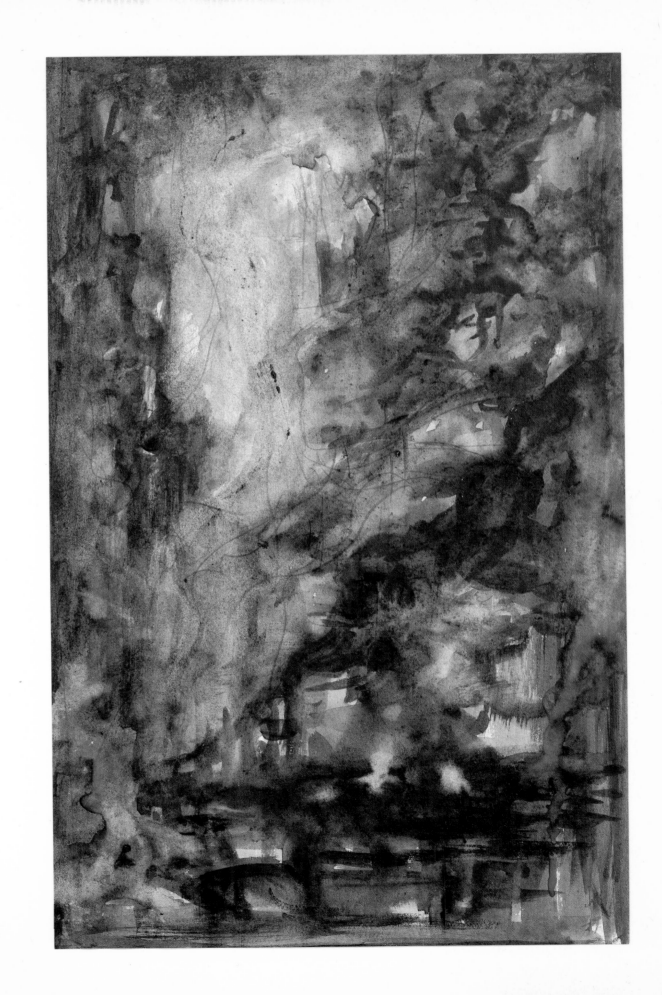

painter. Certainly Kandinsky stayed in Paris in 1906 and 1907, and visited all the galleries. "Kandinsky, who had read Maeterlinck and was a connoisseur of historical evasion, may well have been interested in what one could call the 'troubador symbolism' of Gustave Moreau, and it is not a great leap from Moreau's *Unicorns* to Kandinsky's views of Mother Russia, probably painted between 1903 and 1905. But above all Moreau approaches landscape in an unrealistic and visionary way. He once stated, 'I don't believe in what I touch or see. I only believe in what I don't see, and in what I feel.' The author of *On the Spiritual in Art* (whose very title expresses a point of view) could almost have made that statement. Kandinsky resembles Moreau in so many ways: his insistence on inner needs, his profound spiritualism, and his interest in Symbolism (although he rejected this later in his career)."

Thus a clear link can be drawn between the Symbolism of Gustave Moreau and abstract art, just as we have already seen his more obvious influence on Fauvism (he told his pupils, "I am the bridge over which you will cross") and on Surrealism.

47
VIEW OF THE FRENCH ACADEMY IN ROME
(detail)

Sepia wash over pencil drawing. 1858. 25.5 × 34 cm. Bottom left in brown ink: *Vue de l'académie de France prise de la Villa Borghese 17 avril 1858 5 heures du soir;* signed bottom right: *Gustave Moreau*. Gustave Moreau Museum, Paris

This panorama in sepia was made on the same day as the watercolor showing the gardens of the Villa Borghese, at five o'clock in the evening, as the artist has carefully noted, when the shadows were lengthening. Beyond the park it is possible to make out the Muro Torto which encloses the umbrella pines of the gardens of the Villa Medici, whose two square towers protrude above the trees. In the distance is the silhouette of the dome of Saint Peter's. Although he did not win the Prix de Rome, Moreau was a frequent visitor to the Villa Medici, where he worked with his close friend Edgar Degas, drawing from live models. He associated with some of the residents, such as the painter Elie Delaunay and the composer Georges Bizet.

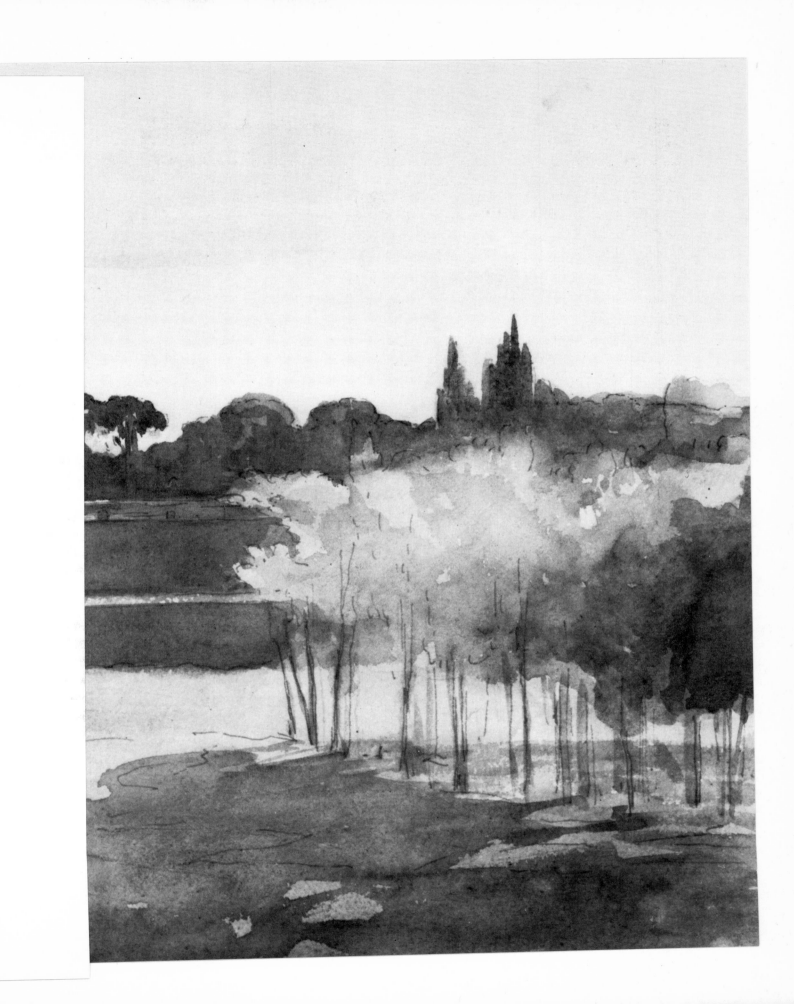

Chronology

1790

Birth of Louis Moreau, the artist's father. At first a departmental architect at Vesoul, a small town in eastern France, later dismissed by Charles X because of his liberal ideas. In 1830 he was made an architectural overseer in the city of Paris, and in 1834 he was charged with the construction of the Place de la Concorde and the exhibition halls for the French Industrial Fair. A cultivated man and an admirer of the eighteenth-century philosophers of the Enlightenment, he published in 1831 a pamphlet that proposed the establishment of an art college that would teach aspiring artists not only technique but also philosophy and literature. He had a great influence on his son, and did not oppose his ambitions, but instead provided him with a solid background in classical art and learning.

1802

Birth of Pauline Desmoutiers, the artist's mother, a good musician and a person of excitable nature. She lived with her son until her death.

1826

6 April: birth of Gustave Moreau at No. 3, rue des Saints-Pères, Paris. He was a small and delicate child.

1836–1840

Secondary studies as a boarder at the Collège Rollin near the Panthéon. After the death of Gustave's sister at the age of thirteen, his parents decided to remove him from the school, as he could not cope with the taller, tougher pupils. From the age of eight he drew all the time, winning his class drawing prize in 1839.

1841

July–October: journey to northern Italy with his mother. He visited Turin, Milan, Mantua, Venice, Parma, Florence, Pisa, and Genoa and returned with a sketchbook full of drawings.

48
THE VILLA BORGHESE

Watercolor. 1858. 28 × 44 cm. Bottom left: monogram *GM Rome Gustave Moreau 1858*; bottom right: *Villa Borghese 17 avril 58.* Gustave Moreau Museum, Paris

Visitors to Rome are rarely able to see these gentle shades of green, which one would more expect to see in an English park. It was in the delicate light of a spring evening that Moreau made this watercolor with its subtle tones and watery, almost transparent colors, the receding planes being indicated by lighter greens. In Moreau's imaginary landscapes one can often find similar trees with powerful trunks and branches, and clusters of tall, thin trees.

1840–1844

While still allowing him to continue his drawing, Moreau's father ensured that he study for, and pass, his *baccalauréat* examinations.

1844

Having shown one of Gustave's paintings to the artist Dedreux-Dorcy, a friend of Géricault, Moreau's father decided to allow his son to become a painter.

1844–1846

Gustave Moreau became a pupil of François Picot, an official painter involved in the decoration of churches and public buildings in Paris. Picot's studio was close to the Moreaus' house. There was life drawing in the mornings and copying from classical sculpture or old master paintings in the Louvre during the afternoons. Picot groomed his students for the Ecole des Beaux-Arts.

1846

October: admitted for the winter term at the Ecole des Beaux-Arts. Moreau was ranked fifty-sixth out of one hundred successful applicants.

1848

April: came in fifteenth out of twenty in the first round of the Prix de Rome competition. (The Prix de Rome was awarded every year to one student at the Ecole des Beaux-Arts; the winner was able to study for several years in Rome.) He did not qualify in the second round.

1849

Moreau competed again for the Prix de Rome and managed to complete both rounds. As one of ten finalists he took part in the last section of the competition, where each artist was given a room in which to work, from May to August, on a single painting. The set subject that year was *Ulysses Recognized by Eurycleia*. He was ill during part of the allotted time, and his painting was not even mentioned by the judges. After this failure he left the Ecole des Beaux-Arts.

1849–1850

Copied paintings in the Louvre, especially Mantegna's, and painted small works, stylistically similar to those of Delacroix, illustrating Shakespeare. Received several commissions through his father.

1851–1852

Became a friend of the painter Théodore Chassériau, a former pupil of Ingres who had turned to Romanticism and whose decorations in the Cour des

49
Acqua Acetosa

Sepia wash over pencil and brown ink drawing. 1858 (postdated 1859). 21 × 28 cm. Signed and dated bottom right: *Gustave Moreau 1859* Rome; at the bottom in brown ink: *Aqua Acetosa, bords du Tibre 20 avril 1858 6 heures du soir eaux violettes lamées de bleu acier jaune orangé laque*. Gustave Moreau Museum, Paris

Along with his watercolors and pastels Moreau left about fifty sepia washes of the Roman Campagna, many of them rather small. These are souvenirs of his excursions along the Tiber in the spring of 1858. In a letter to his parents he wrote, "There is so much to study out in the open, but one must first persevere with what may seem monotonous." On this sepia he noted down the time and the colors of the light as the sun set over the river, just as an Impressionist painter might have done.

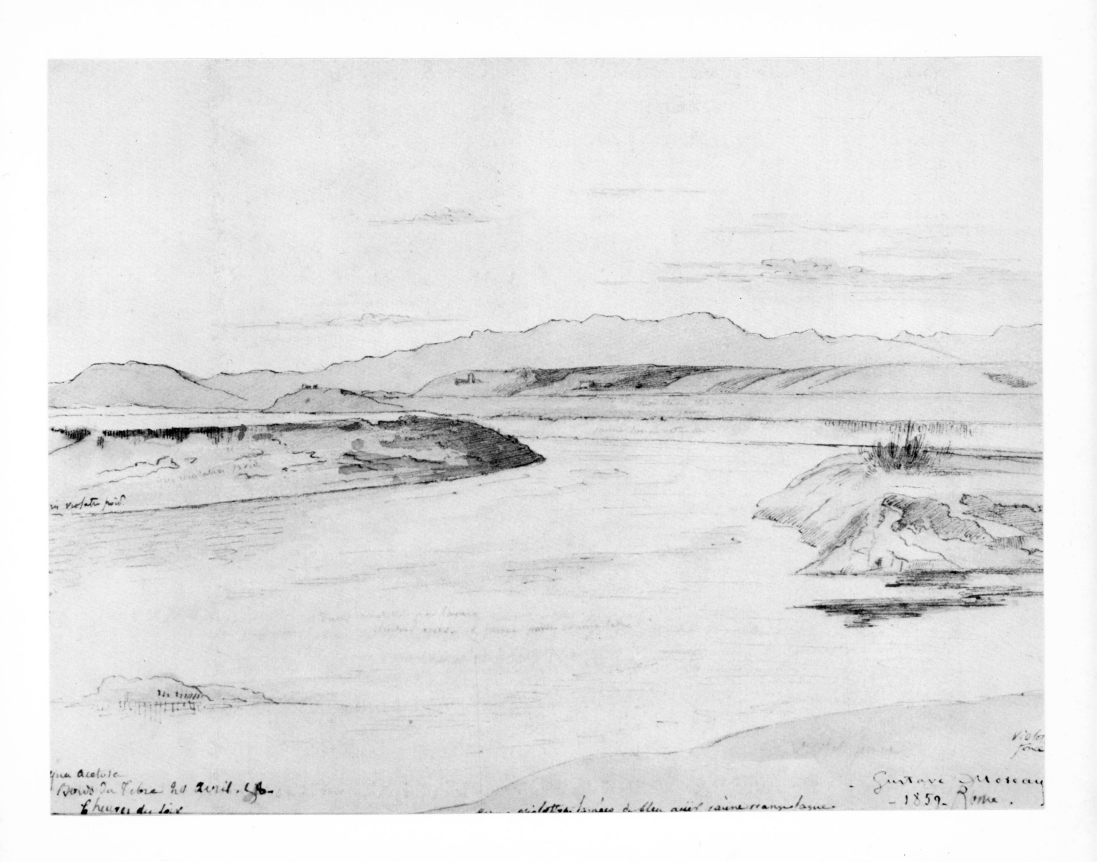

aqua acetosa
Bords du Tibre 20 avril 58
6 heures du soir

Gustave Moreau
- 1859 - Roma.

Comptes had been a great success. Rented a studio close to Chassériau's, near the Place Pigalle, and led a dandified existence, going to the theater and the opera, and singing Gluck, Mozart, and Rossini in smart Parisian society. His work was strongly influenced by Chassériau.

1852

Admitted for the first time to the Salon with a large *Pietà,* which remained unnoticed; began large commissions like *The Suitors.*

1853

Exhibited *The Song of Songs* and *Darius Fleeing after the Battle of Arbela* at the Salon, both close in style to Chassériau. His parents bought a house for him at No. 14, rue Rochefoucauld, where he set up a studio. Began *The Daughters of Thespius.*

1854

Received a commission for *The Athenians Being Given to the Minotaur,* a work shown in the World's Fair exhibition in Paris in 1855. Became friendly with the painter and writer Eugène Fromentin, who visited and consulted with him in his new studio. Moreau provided the painter and engraver Narcisse Berchère with several drawings of subjects from Shakespeare of which Berchère made prints. Did numerous small paintings of horses and horsemen.

1856

Death of Chassériau at the age of thirty-seven. Delacroix wrote in his *Journal:* "Poor Chassériau's funeral. Dauzats was there, also Diaz and the young painter Moreau. I rather like him." Dissatisfied with his work and suffering after an unhappy love affair, Moreau decided to spend two years in Italy to further his education. He was thirty years old.

1857

21 October: departure for Italy with Frédéric Charlot de Courcy, a colleague from his studio. His passport described him as 5 feet 4 inches tall with chestnut hair and beard and brown eyes. In Rome from October 1857 until June 1858: made vigorous oil and watercolor copies of works by Michelangelo, Sodoma, Veronese, Raphael, and Correggio. Recorded his excursions in Rome and in the Campagna in watercolors, sepias, and pastels. Modeled his lifestyle on that of Poussin. Visited Bonnat, Elie Delaunay, and Bizet, the composer, at the Villa Medici (where the winner of the Prix de Rome would normally stay), and got to know the young Edgar Degas, on whom he made a great impression. During June and August he was in Florence, where he copied works by Titian, Uccello, Andrea del Sarto, Pontormo, Bronzino, and Leonardo. At the end of August he was joined by his parents in Milan, where

50
THE PONTE MOLLE ROAD (detail)

Sepia wash over brown-ink drawing. 1858. 19.5 × 36.5 cm. Bottom left: *Rome — Gustave Moreau;* bottom right: *Route de Ponte Mole — Mars 58.* Gustave Moreau Museum, Paris

While in Rome Moreau modeled his existence on that of Poussin, who had also arrived in the city when about thirty years of age. He took a room in the Via del Babuino, close to the house where Poussin had lived, and he traced the master's footsteps along the banks of the Tiber. He even used watercolor, as Poussin had done, to depict places that the seventeenth-century painter had also painted. He even copied one of Poussin's most famous paintings, *The Death of Germanicus,* in a Roman palace. The Ponte Molle road led to the Tiber from Civitavecchia. It passed through countryside punctuated with outcrops, some wooded and others planted with vineyards, on whose slopes prelates and nobles of the papal court had built villas.

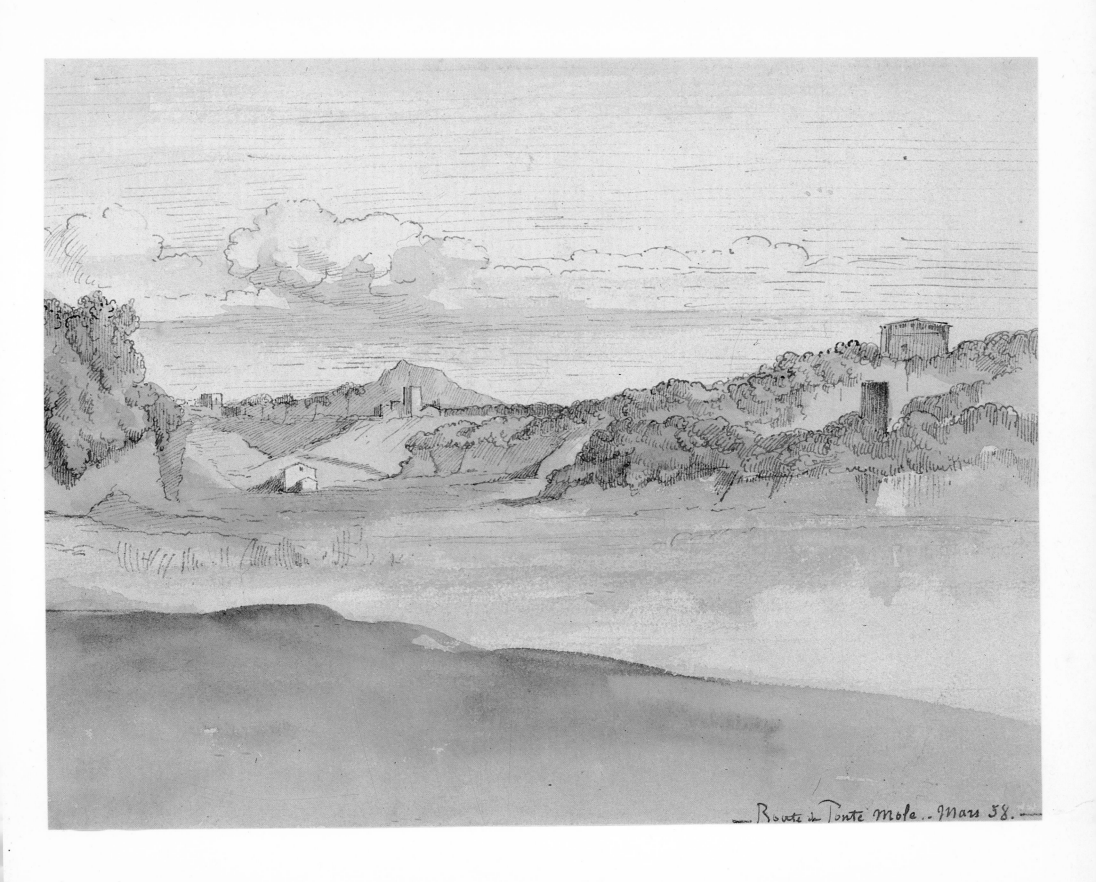

Route de Ponte Mole. Mars 58.

works inspired by poetry: *The Muses Leaving Apollo to Enlighten the World* and *Hesiod and the Muses*.

1869

Showed *Prometheus* and *Jupiter and Europa* at the Salon as well as two watercolors: a *Pietà* and *The Saint and the Poet*. Moreau received a medal but was abused by the critics and did not exhibit at the Salon again until 1876. Théophile Gautier, the poet and influential art critic, wrote: "His strange, deliberately original paintings appeal to the refined, the fastidious, and to the curious."

1870–1871

At the start of the Franco-Prussian war in 1870 Moreau enlisted in the National Guard. In November his arm was paralyzed after an attack of rheumatism contracted while on guard duty on the ramparts of Paris. During the German siege and the Commune, he stayed in his house at the insistence of his mother, who would not run the risk of having her son's work pillaged. Morally and physically drained by the events of the Commune, of which he greatly disapproved, in the summer of 1871 he went to recuperate at Néris-les-Bains.

1874

Refused a commission from the authorities to decorate the chapel of the Virgin at the Panthéon.

1875

Was nominated for Chevalier of the Legion of Honor.

1876

Returned to the Salon to exhibit paintings on which he had long been working: *Salome Dancing, Hercules and the Lernaean Hydra, Saint Sebastian,* and a watercolor, *The Apparition*.

1878

At the Paris World's Fair showed six oil paintings and five watercolors: *The Apparition, Phaeton, Salome in the Garden,* a *Mace-Bearer* and a *Peri*.

1879

Started work on a series of sixty-four watercolors, commissioned by a wealthy patron, illustrating the *Fables* of La Fontaine. This was to occupy him until 1885.

1880

Moreau's last showing at the Salon, with *Helen* and *Galatea*.

52
VENICE

Watercolor. C. 1885. 25.5 × 23.5 cm. Gustave Moreau Museum, Paris

In this ominous vision of Venice, Moreau has chosen to depict only the distant dome of the Salute, as if the rest of the city had sunk beneath the waters. In the foreground an allegorical figure of Venice, supported by the lion of Saint Mark, seems to float on the waters of the lagoon: "Dreaming her dream of grace, grandeur, and silence, the noble queen quietly ponders the memory of past splendors and unfading glory." A similar watercolor, more highly finished but less attractive, is in the Cabinet des Dessins at the Louvre.

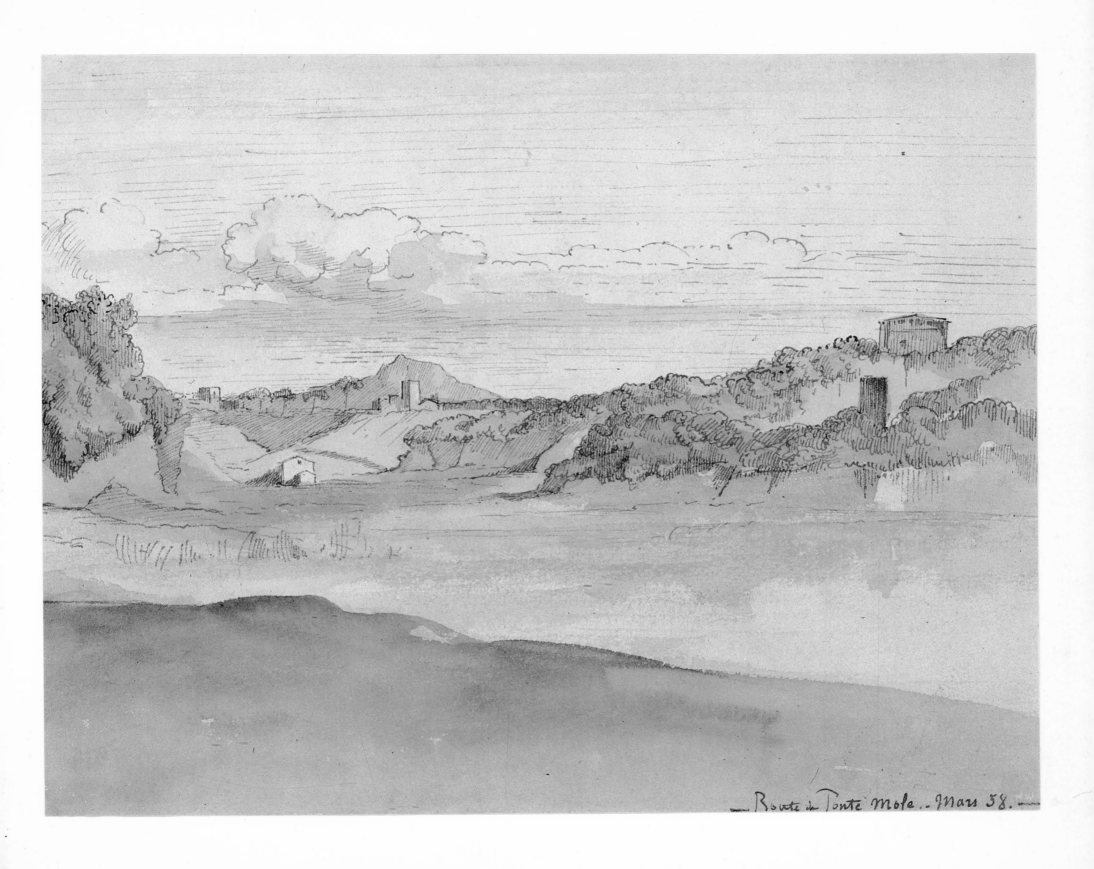

Route de Ponte Mole – Mars 58.

he copied Titian, Luini, and Leonardo. They stayed in Venice from September to December, and Moreau copied Carpaccio, at that time comparatively unknown.

1859

Returned to Florence, where he was eagerly awaited by Degas, and made copies of Titian and Velázquez and of paintings in Santa Maria Novella. Paid a short visit in March to Siena and Pisa, where he copied the frescoes in the Campo Santo. April to June: second stay in Rome, where he made a copy of Poussin's *Death of Germanicus*. From July to September he was in Naples, where he became very interested in the paintings, mosaics, and bronzes from Pompeii and Herculaneum on exhibit in the Museo Borbonico. September: returned to Paris with his parents.

1860

Started work on *Oedipus and the Sphinx, The Three Magi,* and *Tyrtaeus Singing during Battle*.

1862

February: death of his father. Received a commission for fourteen paintings of *The Stations of the Cross* for the church at Decazeville, Aveyron.

1864

Exhibited *Oedipus and the Sphinx* at the Salon: the painting was the most talked about that year and won him a medal. July: went to stay in the country in an uncle's house at Honfleur, where Baudelaire and his mother were neighbors; he did a watercolor of their garden.

1865

At the Salon showed *Jason* and *The Young Man and Death,* begun in 1856 and dedicated to the memory of Chassériau. In November Moreau was invited to the Château de Compiègne by the Emperor Napoleon III, an important mark of approval for an up-and-coming artist. Around this time he got to know Alexandrine-Adélaïde Dureux, born in 1849, a lacemaker. He kept an apartment for her near his studio.

1866

Entered *Diomedes Devoured by His Horses* and *Orpheus* in the Salon, *Orpheus* was bought by the authorities for the Musée du Luxembourg. He also entered two watercolors: *Hesiod and the Muse* and *The Peri*.

1867

Two of Moreau's paintings shown at the World's Fair in Paris: *Orpheus* and *The Young Man and Death*. He did not win any award. He began to paint

51
VIEW OF FLORENCE

Watercolor. 1858. 21.5 × 28 cm. Bottom left: *GM Florence Décembre 1858;* bottom right: *Gustave Moreau*. Gustave Moreau Museum, Paris

Gustave Moreau stayed in Florence at the end of 1858, when he painted this view of the city, which was in its final months as capital of the Grand Duchy of Tuscany. The town is protected by ramparts and slopes, then used as promenades, on which several vague but colorful figures can be seen. In the mist one can make out the hazy shapes of the city's most famous buildings, dominated by Brunelleschi's majestic dome of the cathedral and the somewhat smaller dome of the new sacristy of San Lorenzo built by Michelangelo. To the right is a tower of the fortifications that were soon to be demolished. Among the towers and belfries that dominate the roofs of the town, that of the Palazzo Vecchio stands out with its pointed top.

G.M. Florence Decembre 1858 - Gustave Moreau

works inspired by poetry: *The Muses Leaving Apollo to Enlighten the World* and *Hesiod and the Muses*.

1869

Showed *Prometheus* and *Jupiter and Europa* at the Salon as well as two watercolors: a *Pietà* and *The Saint and the Poet*. Moreau received a medal but was abused by the critics and did not exhibit at the Salon again until 1876. Théophile Gautier, the poet and influential art critic, wrote: "His strange, deliberately original paintings appeal to the refined, the fastidious, and to the curious."

1870–1871

At the start of the Franco-Prussian war in 1870 Moreau enlisted in the National Guard. In November his arm was paralyzed after an attack of rheumatism contracted while on guard duty on the ramparts of Paris. During the German siege and the Commune, he stayed in his house at the insistence of his mother, who would not run the risk of having her son's work pillaged. Morally and physically drained by the events of the Commune, of which he greatly disapproved, in the summer of 1871 he went to recuperate at Néris-les-Bains.

1874

Refused a commission from the authorities to decorate the chapel of the Virgin at the Panthéon.

1875

Was nominated for Chevalier of the Legion of Honor.

1876

Returned to the Salon to exhibit paintings on which he had long been working: *Salome Dancing, Hercules and the Lernaean Hydra, Saint Sebastian,* and a watercolor, *The Apparition*.

1878

At the Paris World's Fair showed six oil paintings and five watercolors: *The Apparition, Phaeton, Salome in the Garden,* a *Mace-Bearer* and a *Peri*.

1879

Started work on a series of sixty-four watercolors, commissioned by a wealthy patron, illustrating the *Fables* of La Fontaine. This was to occupy him until 1885.

1880

Moreau's last showing at the Salon, with *Helen* and *Galatea*.

52
VENICE

Watercolor. C. 1885. 25.5 × 23.5 cm. Gustave Moreau Museum, Paris

In this ominous vision of Venice, Moreau has chosen to depict only the distant dome of the Salute, as if the rest of the city had sunk beneath the waters. In the foreground an allegorical figure of Venice, supported by the lion of Saint Mark, seems to float on the waters of the lagoon: "Dreaming her dream of grace, grandeur, and silence, the noble queen quietly ponders the memory of past splendors and unfading glory." A similar watercolor, more highly finished but less attractive, is in the Cabinet des Dessins at the Louvre.

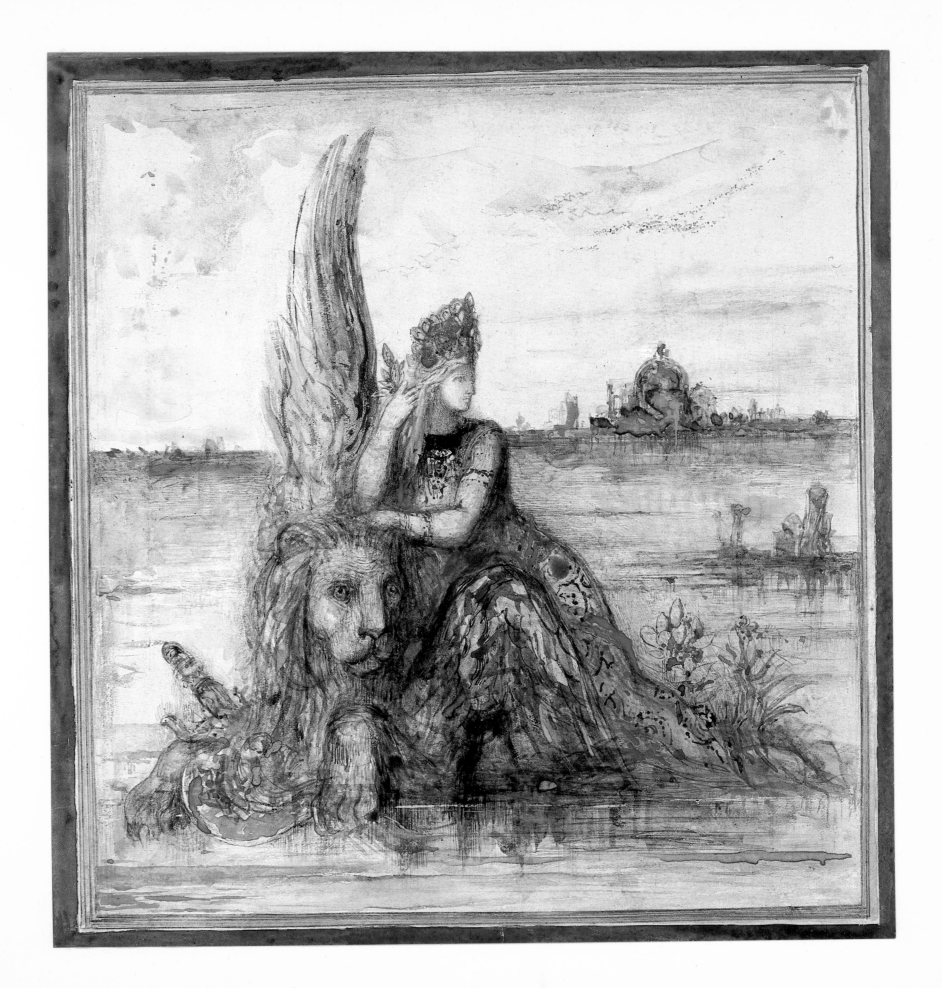

1881

Exhibited the first twenty-five watercolors for the *Fables* at the Cercle des Aquarellistes (Society of Watercolorists) in the rue Laffitte, with the works of various other painters.

1882

Put himself up for election to the Académie des Beaux-Arts, but was unsuccessful.

1883

Was made an Officer of the Legion of Honor.

1884

July: death of his mother.

1886

Finished the polyptych of *The Life of Mankind*. Showed sixty-four watercolors illustrating the *Fables* of La Fontaine and six recent large-scale watercolors at the Goupil Gallery. This was the only exhibition of his work during his lifetime. The engraver Félix Bracquemond made etchings of six of the *Fables* watercolors.

1888

September: traveled to Belgium and Holland to study Flemish painting. In November Moreau was elected to the Académie des Beaux-Arts by a majority of one vote. In December he declined a post as a teacher at the Ecole des Beaux-Arts.

1889

Member of the selection committee for the fine arts section of the Paris World's Fair. He was represented at the centenary exhibition of French art by *The Young Man and Death* and *Galatea*.

1890

March: death of Alexandrine Dureux. Moreau was greatly grieved and painted *Orpheus at the Tomb of Eurydice* in her memory.

1891

Declined to take part in the decoration of the Sorbonne. He provisionally agreed to take over as head of the painting studio at the Ecole des Beaux-Arts after the death of his friend Elie Delaunay.

1892

January: appointed professor in charge of the painting studios at the Ecole des Beaux-Arts, where his pupils included Rouault, Evenepoël, Matisse, Marquet,

Manguin, Piot, Marcel-Béronneau, Maxence, Léon Lehmann, Milcendeau, Bonhomme, and Sabatté. The painter Jacques-Emile Blanche wrote, "I doubt that even M. Ingres had such a hold over his pupils through his way of speaking, his intelligence, his theoretical ideas, and his devotion to his art and his skills." On Sundays he received his pupils at home, and some visited him alone, such as Georges Desvallières and the future filmmaker Georges Méliès.

1894
Commissioned to make a tapestry cartoon for the Gobelins factory: *The Poet and the Siren.*

1895
August: while at Evian for a cure, went to Basel to see the Holbein paintings. He began to build two exhibition rooms above his house in Paris to contain a museum of his works after his death. Finished *Jupiter and Semele.*

1897
Became aware of the first signs of stomach cancer; made his will in which he bequeathed his house and studio to the French state. Annotated his drawings and watercolors.

1898
18 April: death of Gustave Moreau. Funeral in the church of the Trinity, Paris. Buried in his parents' vault at the cemetery of Montmartre, close to the tomb of Alexandrine Dureux, which he had had modeled on his own.

1899
Henri Rupp, executor of the painter's will, organized the Gustave Moreau Museum while the authorities debated whether to take it on.

1902
The state accepted the gift on condition that Henri Rupp relinquish his part of the bequest to pay for the maintenance of the museum.

1903
Official opening of the Gustave Moreau Museum. The first curator was the artist's favorite pupil, Georges Rouault.

1906
Retrospective exhibition of 209 of Gustave Moreau's works, 135 of them watercolors, at the Georges Petit Gallery.

1961
Gustave Moreau exhibition held at the Louvre at the instigation of André Malraux.

Bibliography

This bibliography is confined to books and articles to which reference is made in the text and captions. A full list of works on Gustave Moreau will be found in:

Mathieu, P.-L., *Gustave Moreau. Sa vie, son œuvre. Catalogue raisonné de l'œuvre achevé*, Fribourg, 1976 (in English, French, German, and Japanese).

Kaplan, J., *The Art of Gustave Moreau. Theory, Style and Content*, Ann Arbor, Michigan, 1982.

I Catalogues of Works

Catalogue des peintures, cartons et aquarelles du Musée Gustave Moreau, by H. Rupp and J. Paladilhe, Paris, 1974 (1179 items).

Catalogue des dessins de Gustave Moreau au Musée Gustave Moreau, by P. Bittler and P.-L. Mathieu, Paris, 1983 (4831 items).

Catalogue de l'œuvre achevé (except those in the Musée Gustave Moreau), cf. P.-L. Mathieu, op. cit. (428 items).

Catalogue raisonné du Cabinet des Dessins du Musée du Louvre—Ecole française, by G. Rouchès and R. Huyghe, Paris, 1938.

II Works by Gustave Moreau

Most of the artist's publications consist of commentaries on his artistic works. Many have been edited by P.-L. Mathieu and J. Paladilhe under the title: *L'Assembleur de rêves. Commentaires de tableaux et écrits complets*, Fata Morgana, Montpellier, 1984.

III Books and Articles

ALAIN, *Vingt leçons sur les beaux-arts*, Paris, 1931.

ALEXANDRIAN, S., *L'Univers de Gustave Moreau*, Paris, 1975.

AURIER, G.-A., *Œuvres posthumes*, Paris, 1893.

BATAILLE, G., "Gustave Moreau l'attardé, précurseur du surréalisme," in: *Arts*, June 7, 1961.

BÉNÉDITE, L., "Deux idéalistes: Gustave Moreau et Edward Burne-Jones," in: *La Revue de l'art ancien et moderne*, Paris, 1899.

BLANCHE, J.-E., *Les Arts plastiques sous la IIIᵉ République*, Paris, 1931.

BOISSE, L., "Le Paysage et la nature dans l'œuvre de Gustave Moreau," in: *Mercure de France*, February 1, 1917.

BRETON, A., *Le Surréalisme et la peinture*, Paris, 1965.

—— and LEGRAND, G., *L'Art magique*, Paris, 1957.

CAILLOIS, R., *Au Cœur du fantastique*, Paris, 1965.

CAZALIS, H., "Gustave Moreau et les Fables de La Fontaine," in: *Les Lettres et les arts*, April 1886.

DAULTE, F., *L'Aquarelle française au XIXᵉ siècle*, Fribourg, 1969.

DENIS, M., *Histoire de l'art religieux*, Paris, 1939.

EVENEPOËL, H., *Lettres choisies* (ed. F.E. Hyslop), Brussels, 1971.

FALIZE, L., "Claudius Popelin et la renaissance des émaux peints," in: *Gazette des beaux-arts*, Paris, vols. IX, X, XI, 1894 and 1895.

FLAT, P., *Le Musée Gustave Moreau. L'Artiste, son œuvre, son influence*, Paris, 1899.

FÉNÉON, F., *Œuvres plus que complètes*, Paris, 1970.

GONCOURT, E. DE, *Journal*, Paris, 1956.

HAHLBROCK, P., *Gustave Moreau oder das Unbehagen in der Natur*, Berlin, 1976.

HAUTECŒUR, L., "Le Symbolisme et la peinture," in: *Revue de Paris*, July 1, 1936.

HOLTEN, R. VON, *L'art fantastique de Gustave Moreau*, Paris, 1960.

—— "Gustave Moreau, illustrateur de La Fontaine," in: *L'Œil*, July–August 1964.

HOOG, M., "Kandinsky et la peinture française," in: *Kandinsky à Munich*, Bordeaux, 1976 (exhibition catalogue).

HUYSMANS, J.-K., *L'Art moderne*, Paris, 1883.

—— *A Rebours*, Paris, 1884.

—— *Certains*, Paris, 1889.

JENKINS, P., "Gustave Moreau, moot grandfather of abstraction," in: *Art News*, December 1961.

KANDINSKY, W., *On the Spiritual in Art*. First complete English translation by H. Rebay, New York, 1946.

—— *Regards sur le passé et autres textes (1912–1922)*, ed. J.-P. Bouillon, Paris, 1974.

KAPLAN, J., *Gustave Moreau*, Los Angeles, 1974 (exhibition catalogue).

LARROUMET, G., "Le Symbolisme de Gustave Moreau," in: *La Revue de Paris*, September 15, 1895.

LEMAITRE, H., *Le Paysage anglais à l'aquarelle*, Paris, 1955.

LEPRIEUR, P., "Gustave Moreau et son œuvre," in: *L'Artiste*, March, May, and June 1889.

MATHIEU, P.-L., "La Bibliothèque de Gustave Moreau," in: *Gazette des beaux-arts*, April 1978.

—— "Gustave Moreau, premier abstrait?" in: *Connaissance des arts*, December 1980.

MONTESQUIOU, R. DE, *Altesses sérénissimes*, Paris, 1907.

PALADILHE, J., *Gustave Moreau*, Paris, 1971.

PANOFSKY, E., *Essais d'iconologie*, Paris, 1967.

PIERROT, J., *L'Imaginaire décadent (1880–1900)*, Paris, 1977.

PRAZ, M., *La Chair, la mort et le diable*, Paris, 1977.

PROUST, M., *A la recherche du temps perdu*, Paris, 1961.

—— *Contre Sainte-Beuve*, Paris, 1971.

RÉAU, L., *Un Siècle d'aquarelle. De Géricault à nos jours*, Paris, 1942 (exhibition catalogue).

REDON, O., *A Soi-même. Journal (1867–1915)*, Paris, 1922.

—— *Lettres (1878–1916)*, Paris, 1923.

RENAN, A., *Gustave Moreau*, Paris, 1900.

ROBBE-GRILLET, A., "La Chambre secrète," in: *Instantanés*, Paris, 1962.

SÉBASTIANI-PICARD, O., "L'Influence de Michel-Ange sur Gustave Moreau," in: *La Revue du Louvre*, no. 3, 1977.

SEGALEN, V., *Gustave Moreau, maître imagier de l'orphisme*, 1908, unpublished MS.

SÉRULLAZ, A. and MICHEL, R., *L'Aquarelle en France au XIXͤ siècle. Dessins du Musée du Louvre*, Paris, 1983 (exhibition catalogue).

SÉRULLAZ, M., CALVET, A., DUNOYER, L. and MONNIER, G., *Dessins français de Prud'hon à Daumier*, Fribourg, 1966.

VALÉRY, P., *Degas. Danse. Dessin*, Paris, 1965.

ZOLA, E., *Le Bon Combat. Anthologie d'écrits sur l'art*, with a foreword by J.-P. Bouillon, Paris, 1974.

—— *L'Œuvre*, in: *Les Rougon-Macquart*, Paris, 1966.

Acknowledgments

The author wishes to thank the many museum keepers, art historians, private collectors, and photographers who have helped to produce this volume.

In particular he wishes to express his gratitude to the Musée Gustave Moreau, its keeper, M. Jean Paladilhe, its administrator, M. Paul Bittler, the Cabinet des Dessins of the Musée du Louvre, and the various museums in France and elsewhere that have made possible the illustrations in this volume, as well as the private connoisseurs who permitted reproduction of works they own.

Finally we may mention M. Jean Hirschen, who kindly endorsed our proposal to publish another work on Gustave Moreau, devoted solely to his watercolors.

Photo Credits

The museums and galleries listed below have kindly permitted photographs to be published of the following works, identified here by the number of the illustration. The photographic material was assembled by Ingrid de Kalbermatten.

AGRACI, Paris 32
Bulloz, Paris 3, 33, 36, 37, 38
National Gallery of Canada, Ottawa 5
Hans Hinz, Allschwil 18, 22, 24, 25, 26, 27, 30, 31, 34, 35, 41, 42, 43, 44, 50, 52
Walter Klein, Düsseldorf 19
Ohara Museum of Art, Kurashiki 40
Réunion des Musées Nationaux, Paris 2, 8, 11, 14, 21, 23, 29, 39
Georges Routhier, Studio Lourmel, Paris 1, 6, 7, 9, 12, 13, 16, 17, 20, 28, 45, 46, 47, 49
Victoria and Albert Museum, London 15

Author's archives 48, 51 (photographs Fr. Foliot); 4, 10

Index